Darfur Twenty Years of War and Genocide in Sudan

Edited by Leora Kahn

pH powerHouse Books
Brooklyn, NY

In the end, we will remember not the works of our enemies but the silence of our friends.
Martin Luther King Jr.

This book is dedicated to victims of genocide everywhere

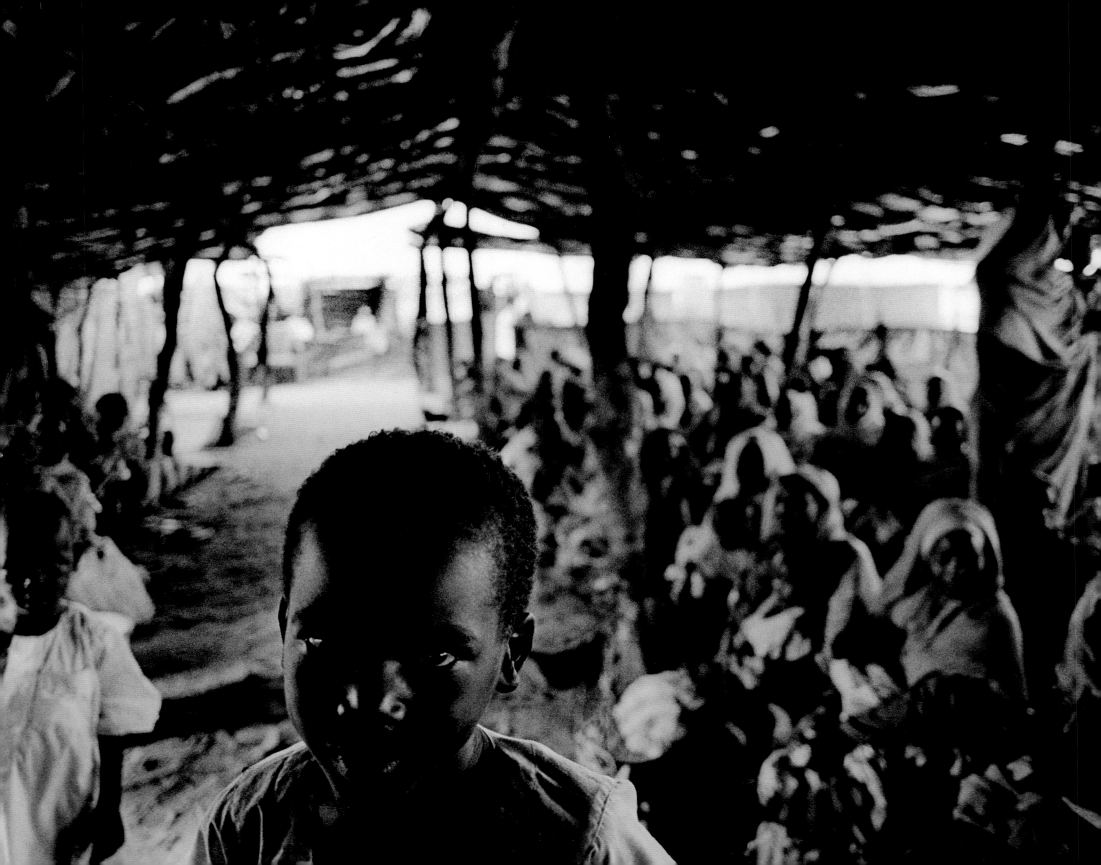

Introduction

Darfur is situated in the west of Sudan and covers an area the size of France. For a number of years it was the scene of sporadic clashes between farming communities such as the Fur, Masalit, and Zaghawa, and nomadic groups, which led to many deaths and the destruction and looting of homes. The government blamed competition over scarce resources for the clashes.

In February 2003 a newly armed opposition group, the Sudan Liberation Army (S.L.A.) took up arms against the government, because of what they perceived as a lack of protection for their people and the marginalization and underdevelopment of the region. The support base of this armed group came mainly from the agricultural groups in the region. Shortly afterwards another armed group, the Justice and Equality Movement (J.E.M.) emerged.

The government of Sudan responded by allowing free rein to Arab militias known as the janjaweed (guns on horseback), who began attacking villages, killing, raping, and abducting people, destroying homes and other property, including water sources, and looting livestock. At times government troops also attacked villages alongside the janjaweed, and government aircraft have been bombing villages, sometimes just before janjaweed attacks, suggesting that these attacks are coordinated. The links between the Sudanese armed forces and the janjaweed are incontrovertible, the janjaweed are now wearing uniforms provided by the army.

Hundreds of thousands of people have been forcibly displaced from their homes as a result of actions by the janjaweed, government forces, and rebel groups. The U.N. estimates that there are now over 2 million internally displaced people in Darfur who have fled from their burnt villages and taken refuge within Darfur, mostly in towns and camps, often in very poor conditions, while more than 200,000 have crossed the border into Chad.

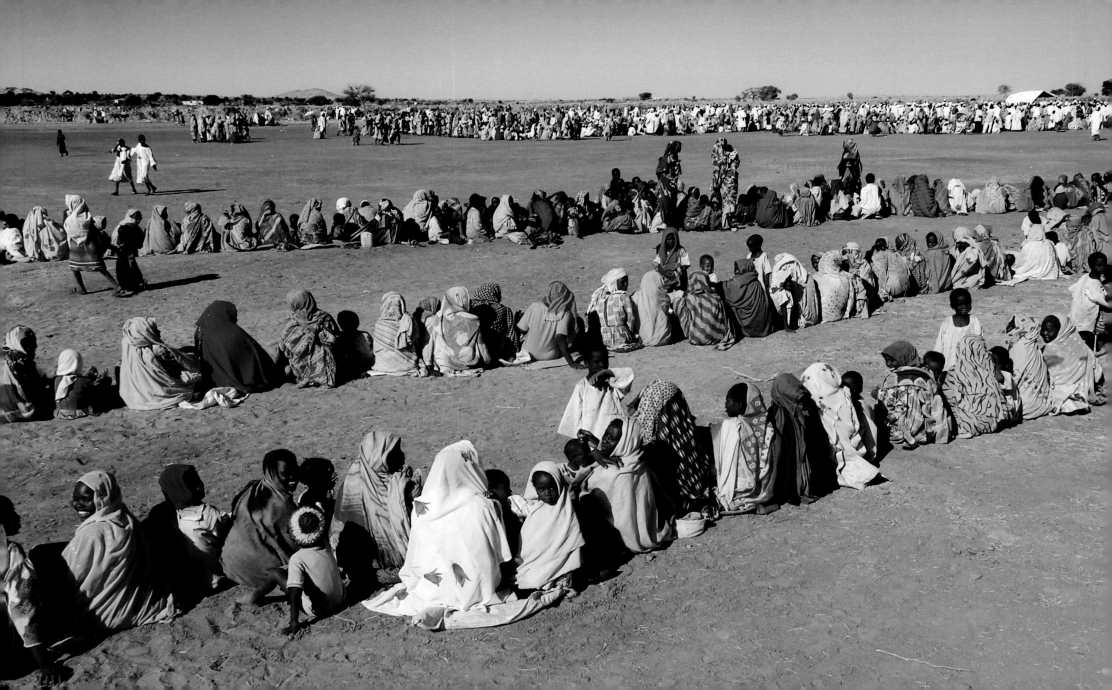

Finlay

las D. Kristof

r

Prendergast

d *Ryan Gosling*
Chad as in Darfur *Mia Farrow*
Centers
an Myers
hies

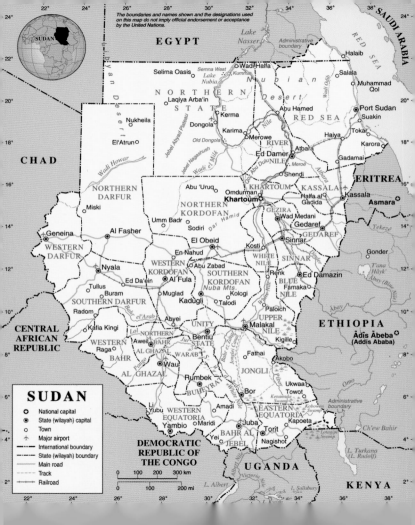

Advent of oil

1999 Sudan begins to export oil.

2000 September President Bashir meets for the first time with leaders of opposition National Democratic Alliance in Eritrea.

2000 December Bashir re-elected for another five years in elections boycotted by main opposition parties.

2001 February Islamist leader Hassan al-Turabi arrested a day after his party, the Popular National Congress, signed memorandum of understanding with the southern rebel S.P.L.A.

Food shortages

2001 March U.N.'s World Food Program struggles to raise funds to feed 3 million facing famine.

2001 June Failure of Nairobi peace talks attended by President al-Bashir and rebel leader John Garang.

2001 September U.N. lifts largely symbolic sanctions against Sudan imposed in 1996 over accusations that Sudan harbored suspects who attempted to kill Egyptian President Hosni Mubarak.

2001 November U.S. extends unilateral sanctions against Sudan for another year, citing its record on terrorism and rights violations.

Ceasefire deal

2002 January S.P.L.A. joins forces with rival militia group Sudan People's Defense Force against government in Khartoum.

2002 July Government and S.P.L.A. sign Machakos Protocol on ending nineteen-year civil war. Government accepts right of south to seek self-determination after six-year interim period.

2002 October Government and S.P.L.A. agree to ceasefire but hostilities continue.

2003 February Rebels in western region of Darfur rise up against government, claiming the region is being neglected by Khartoum.

2003 October Popular National Congress leader Turabi released after nearly three years in detention and ban on his party is lifted.

2003 November Chadian government declares state of emergency.

Darfur crisis

2004 January Army moves to end rebel uprising in western region of Darfur; hundreds of thousands of refugees flee to neighboring Chad.

2004 March U.N. official says pro-government Arab "janjaweed" militias are carrying out systematic killings of African villagers in Darfur.

2004 September U.N. says Sudan has not disarmed pro-government Darfur militias and must accept outside help to protect civilians. US Secretary of State Colin Powell describes Darfur killings as genocide.

2005 January Government and southern rebels sign a peace deal. The agreement includes a permanent ceasefire and accords on wealth and power sharing. U.N. report accuses the government and militias of systematic abuses in Darfur, but stops short of calling the violence genocide.

2005 March U.N. Security Council authorizes sanctions against those who violate ceasefire in Darfur and also votes to refer those accused of war crimes in Darfur to International Criminal Court.

Southern autonomy

2005 July Former southern rebel leader John Garang is sworn in as first vice president of Sudan. A constitution that gives a large degree of autonomy to the south is signed.

2005 August Vice President Garang is killed in a plane crash. He is succeeded by Salva Kiir. Garang's death sparks deadly clashes in the capital between southern Sudanese and northern Arabs.

2005 September Power-sharing government is formed in Khartoum.

2006 May Khartoum government and the main rebel faction in Darfur, the Sudan Liberation Movement, sign a peace accord. Two smaller rebel groups reject the deal. Fighting continues.

2006 August Sudan rejects a United Nations resolution calling for a U.N. peacekeeping force in Darfur, saying it would compromise Sudanese sovereignty.

2006 September Sudan says African Union troops must leave Darfur when their mandate expires at the end of the month, raising fears that the region would descend into full-blown war.

2006 October Jan Pronk, the U.N.'s top official in Sudan, is expelled.

Then:
1988 to 1998

Never Again? Hope for Darfur, Hope for the Future

Larry Cox, Executive Director of Amnesty International USA

Words are not enough. The people of Darfur need action now.

Photographs often inform people. They also often move people. Images can show us a reality that words fail to create. Sometimes the reality is something we would rather not try to imagine. It is my hope that the photos contained in this book not only inform you, but also move you to action. It is true that one person cannot solve the world's problems, but one person joined by a million more can certainly create change.

It's difficult to imagine what's happening in Darfur. Joseph Stalin once said that one death is a tragedy and one million deaths are a statistic. It's not easy for people who haven't been to a place like Darfur to imagine the horror of what's happening there on a daily basis. This book brings us a powerful awareness of the injustices occurring daily by putting a human face on the statistics we've all read about.

There are no words that can describe the horror of what is going in Darfur every day—the killings, the rapes, the burning of villages, the driving of millions of people from their homes to be imprisoned in camps of destitution. There are no words that can adequately describe the "human rights catastrophe" when already more than 400,000 have died, more than 2 million have been driven from their homes, and 3.5 million

now rely on international aid for survival . And there are no more words to describe the shame of a world which has stood by and watched as the killings and rapes and burnings have continued to grow worse.

"We have still not summoned up the collective sense of urgency that this issue requires," said Kofi Annan, U.N. Secretary General, who pledged to make the killings in Darfur his priority. The conflict in Darfur has led to some of the worst human rights abuses imaginable, including systematic and wide-scale murder, rape, torture, abduction, and displacement. Thanks to pressure from Amnesty activists and their allies, President Bush signed a bill in June 2006 that would support efforts to stop the violence. But there's still a long way to go to put an end to the conflict.

What have we learned since the human rights catastrophes of the past? A generation after the closing of the Nazi death camps—after which governments around the world shouted "never again"—and thirty years since the horrors of the Cambodian killing fields—when "never again" was echoed once more—we face unimaginable killings and human suffering today in Darfur. What will it take to make the words we preach be put into practice? It can start right now by taking action and doing something, even if it's just one thing. Your action, joined by many others, will make a difference. We must not loose hope; not only for ourselves, but for the people suffering in Darfur and for the fate of humanity.

Today is the day you can make a difference. You can join the 1.2 million Amnesty International members worldwide and raise your voice on behalf of those the powerful have ignored and shine a light on the injustices that would have preferred darkness. For over forty-five years, Amnesty International has joined people together to help create change. Whether it's writing letters or going to a demonstration, we try to identify what you can do to make a difference. We have helped change unjust laws and freed over 42,000 prisoners of conscience around the world. It's more difficult when it comes to what's happening Darfur, but it's not impossible. We have proven the power people can have when they join together and raise their voices for a cause. It's so important to just do something, and the best time to start is now, today.

Together, let's help make the words "never again" a reality. I hope these images compel you to do something on behalf of the people suffering each day in Darfur. Your voice is a crucial part of this effort.

Visit our website at www.amnestyusa.org and start changing the world today.

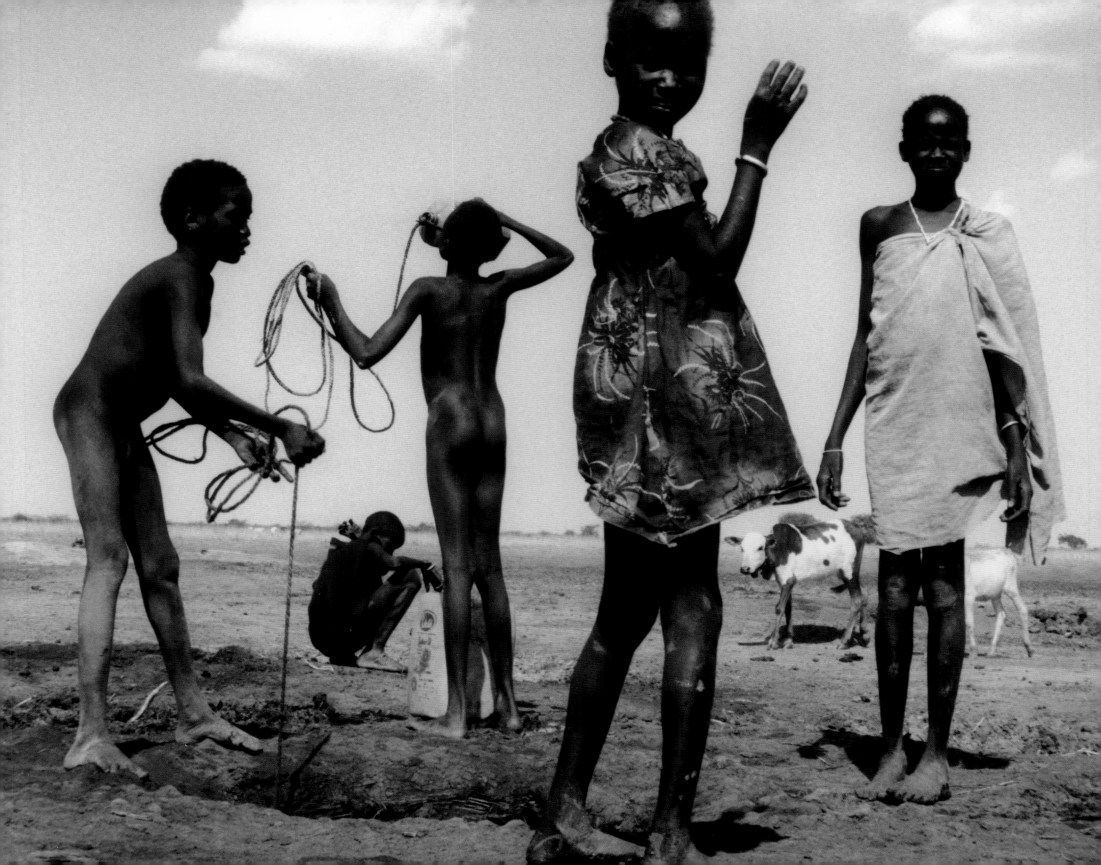

The People

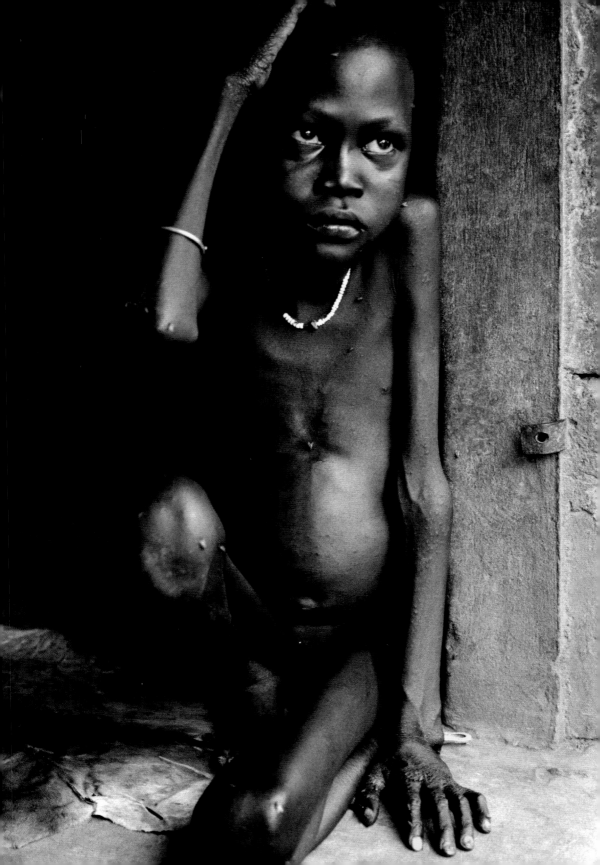

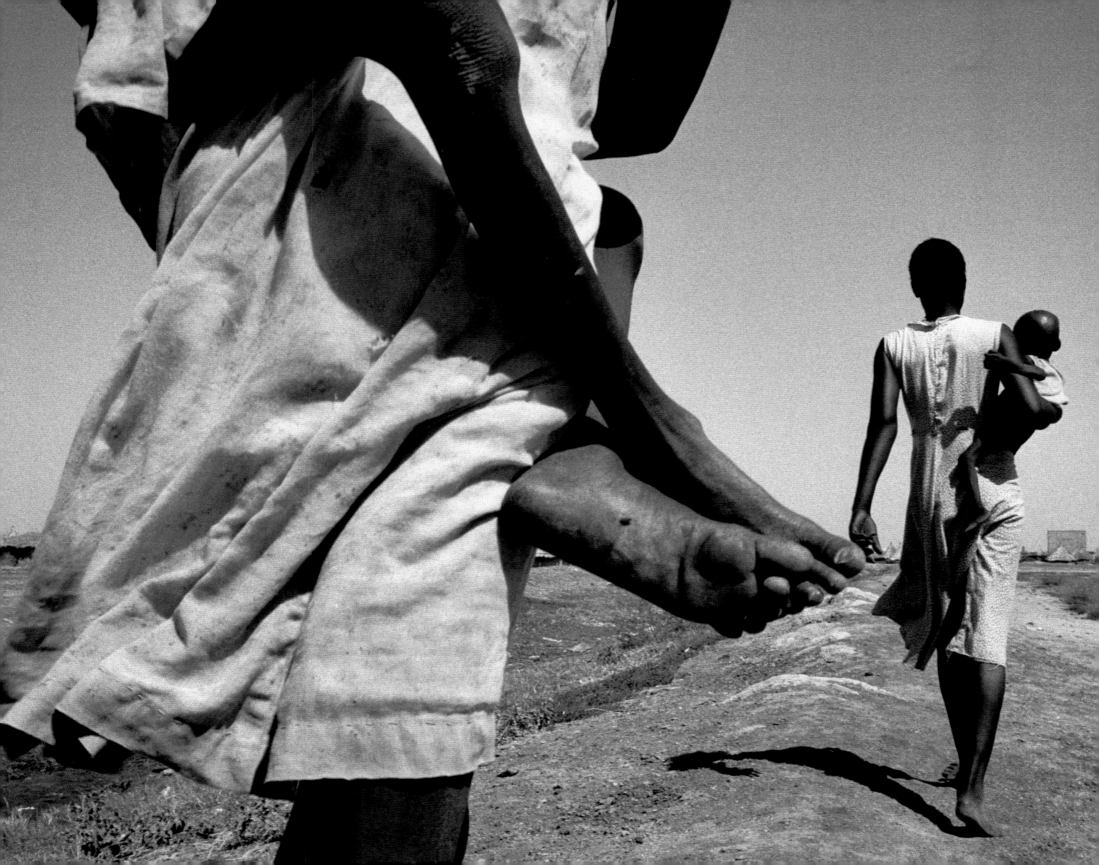

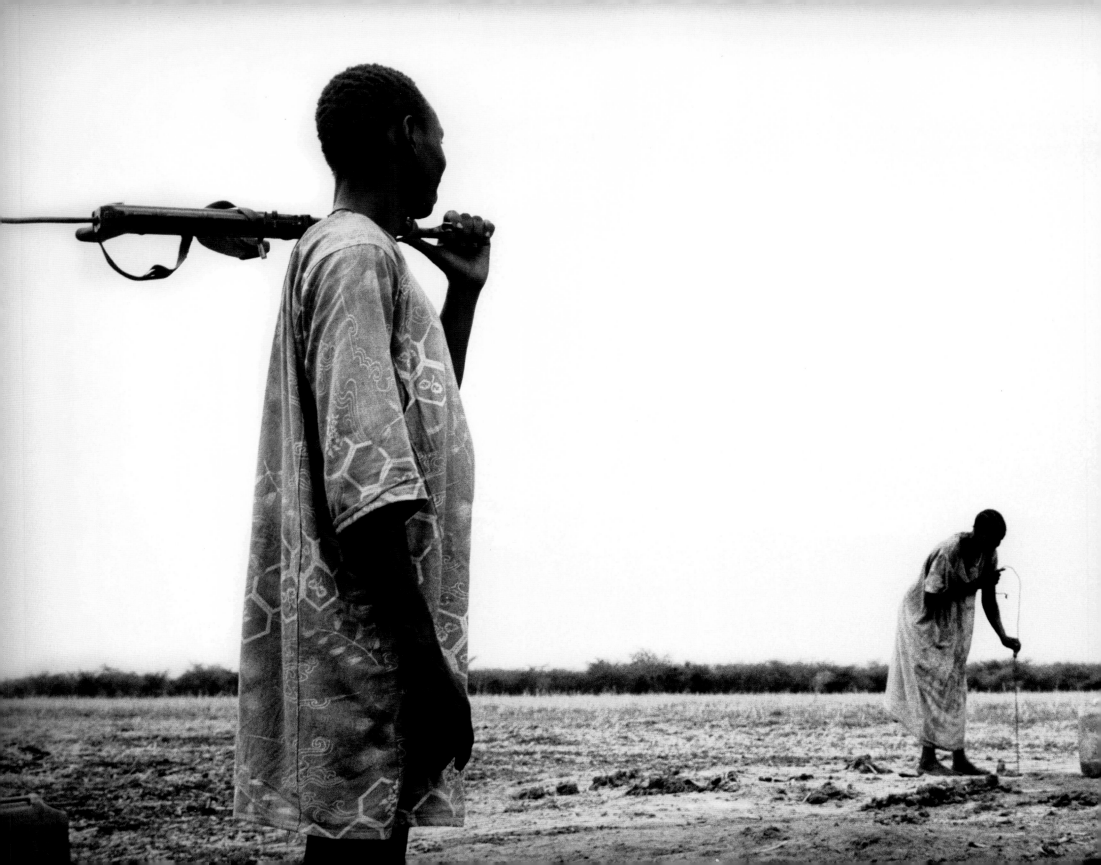

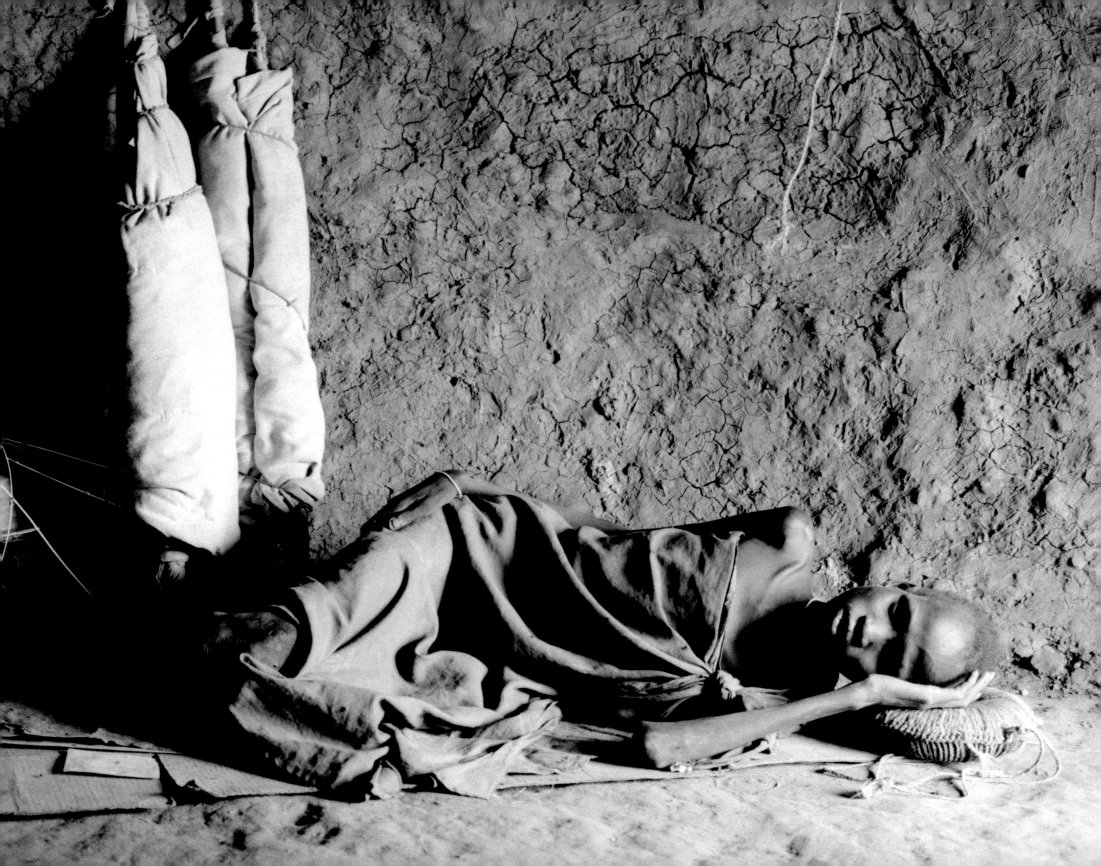

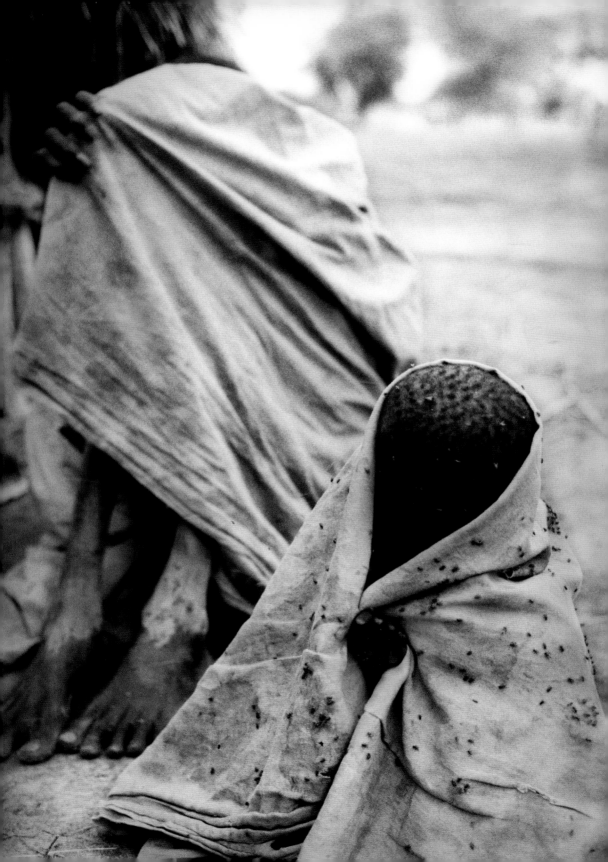

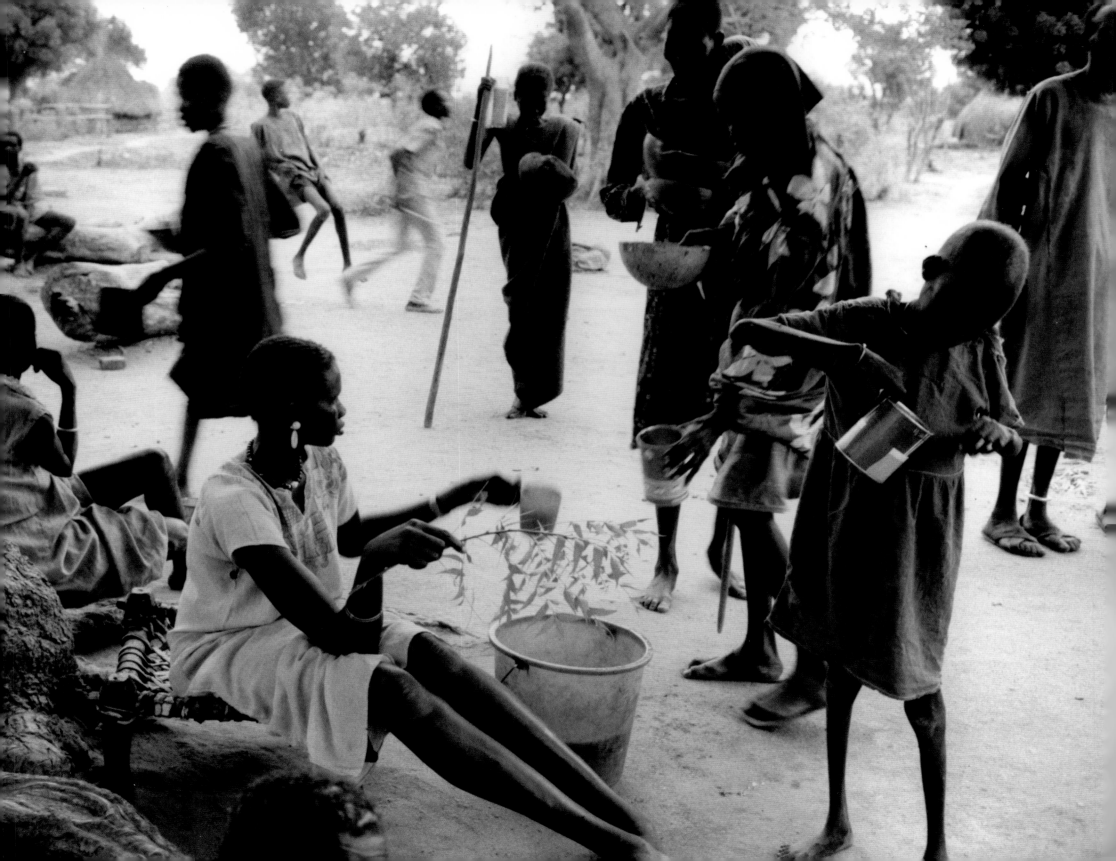

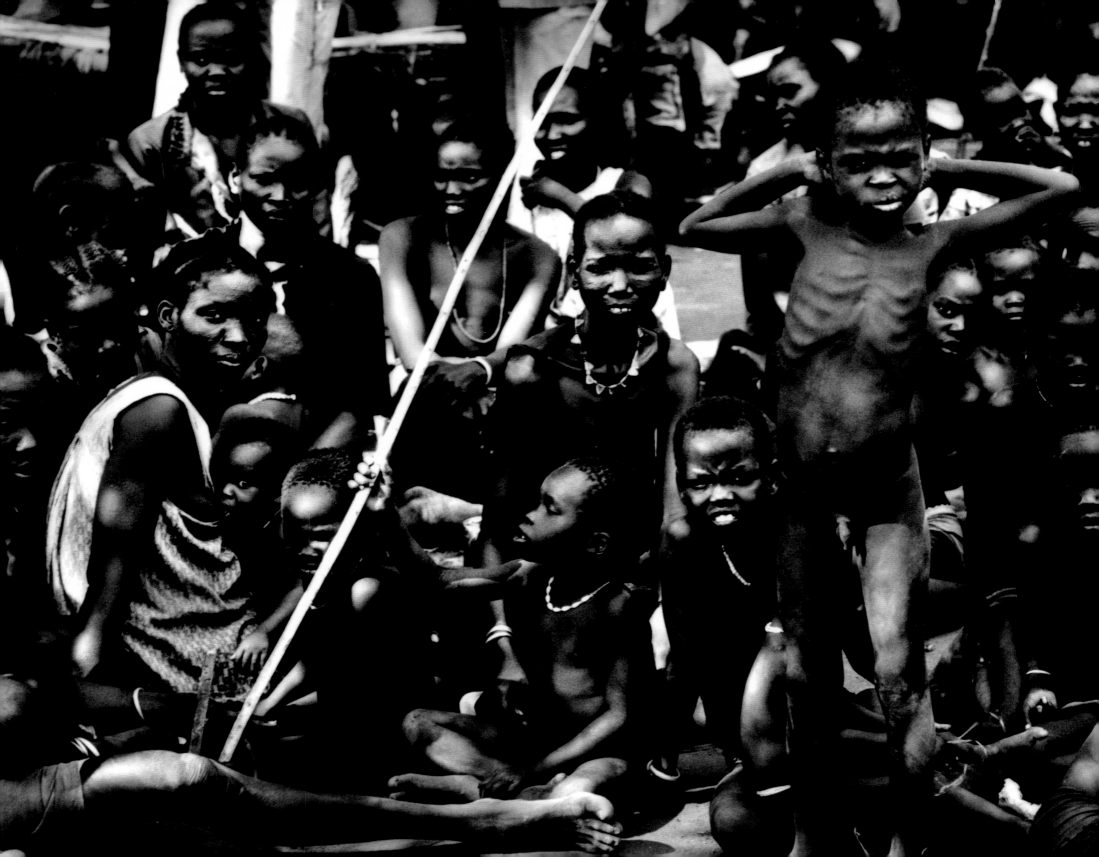

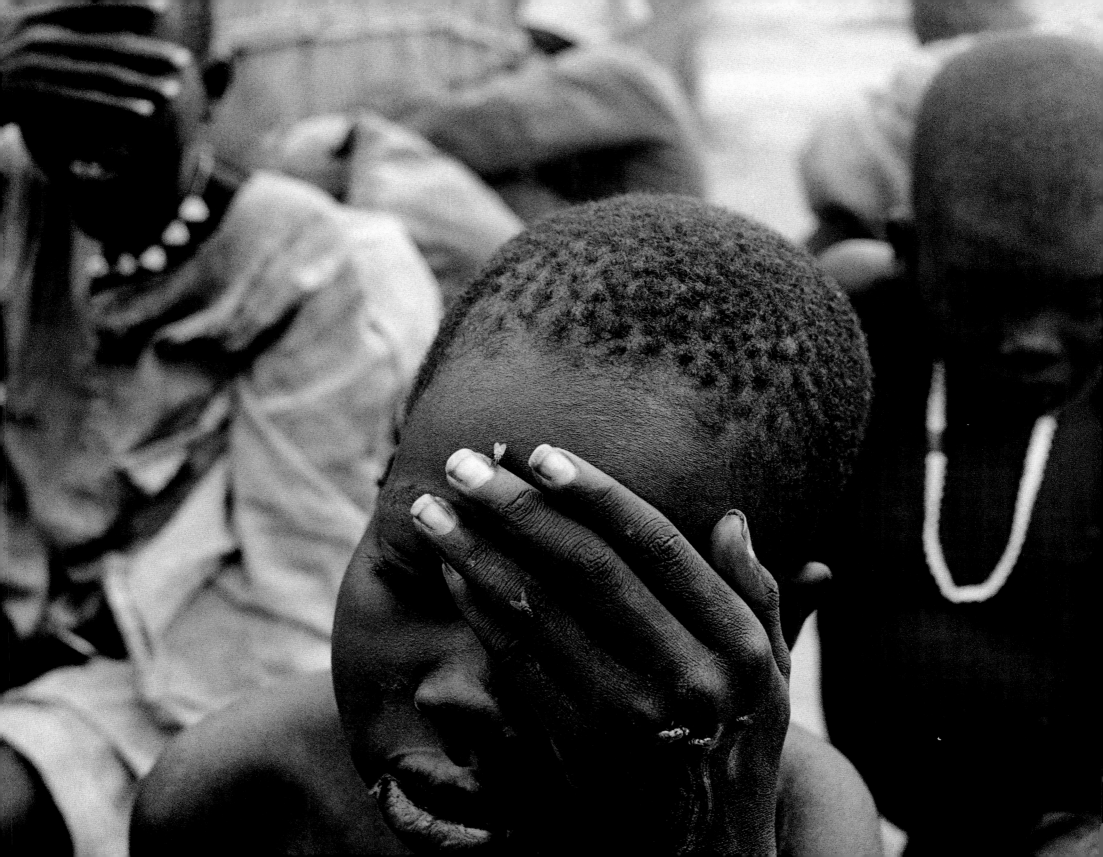

Ajiep, Sudan, 1998
Colin Finlay

Ajiep, where life begins and ends. A disparate and shattered sleeping giant. In the death of a desert afternoon, I stepped off a small prop plane and fell into another world. That was Africa. She had given birth to me in this fashion many times before. It was September and I was in a lost, forgotten landscape named Ajiep, somewhere in the midst of southern Sudan. Over the edge of reality, the edge of sanity, the edge of civilization, I found a gaping hole fulled with people the world no longer wanted. There was the dead body, stuffed into a latrine by someone too tired and weak to bury it, crawling with a thousand maggots and caught in a silver shaft of early morning light as I awoke to relieve myself. This is famine. There are no tears for the dead and dying. The children, now too weak to cry, sit in silence, alone. Unless they are within twenty-four hours of death, they will not be seen to.
In the midst of all this, a Parisian is on her hands and knees, washing the feet of a dying woman. A photograph could never capture the dignity of such a human gesture; it was one of the most beautiful moments I have ever seen. I had passed the dying woman earlier, lying in the back of a long, narrow canvas tent. She was motionless, alone, no I.V. lifeline attached to her arm, no tubes through her nose. I could only assume the worst. She had been culled from the herd of the living. I moved slowly, photographing outside and around the tent. The landscape was fractured, full of lives caught in slow decay.

At times it feels there are just too many people. There is a black hole of humanity in this universe. It is Ajiep. I am raw, vulnerable, and cry in an instant, but I always catch myself. Rwanda taught me that.

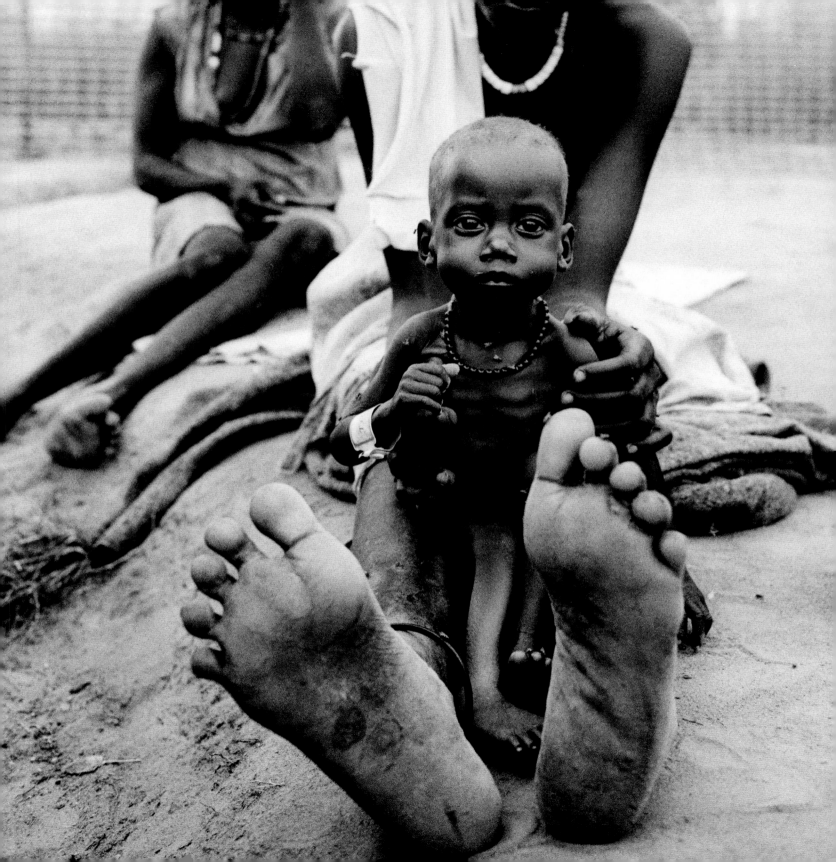

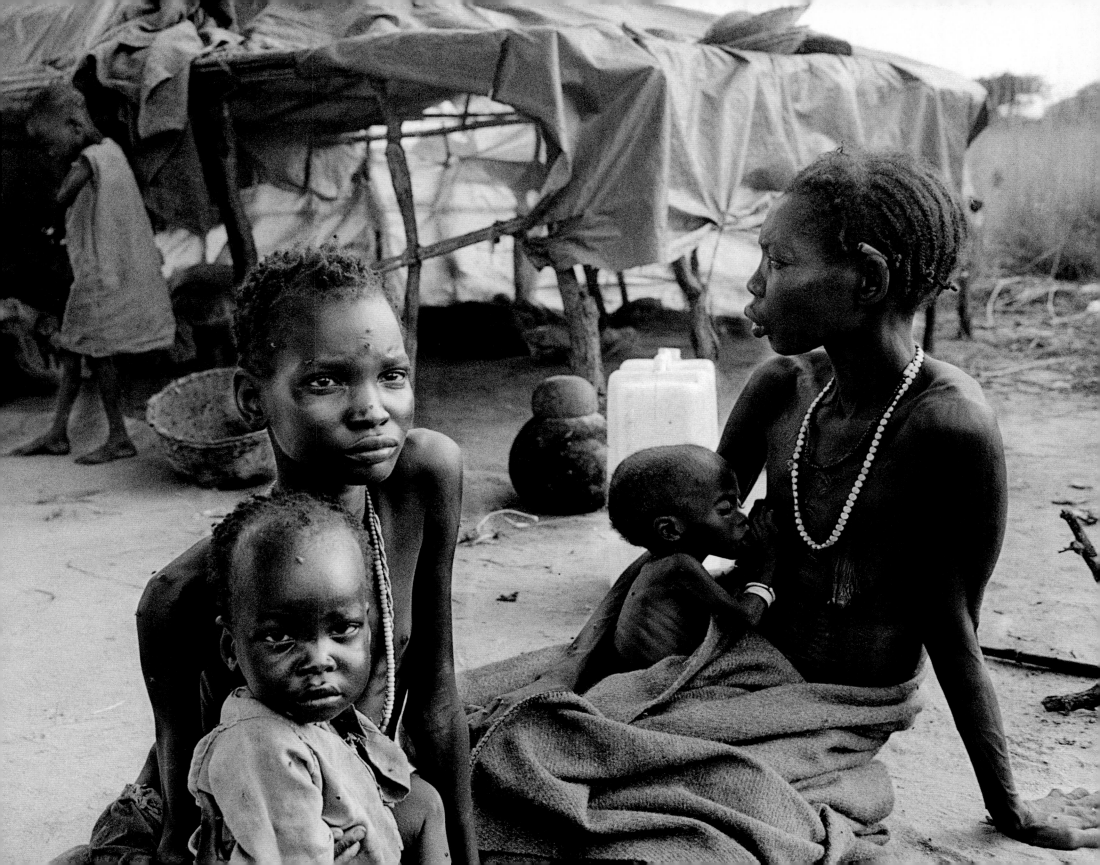

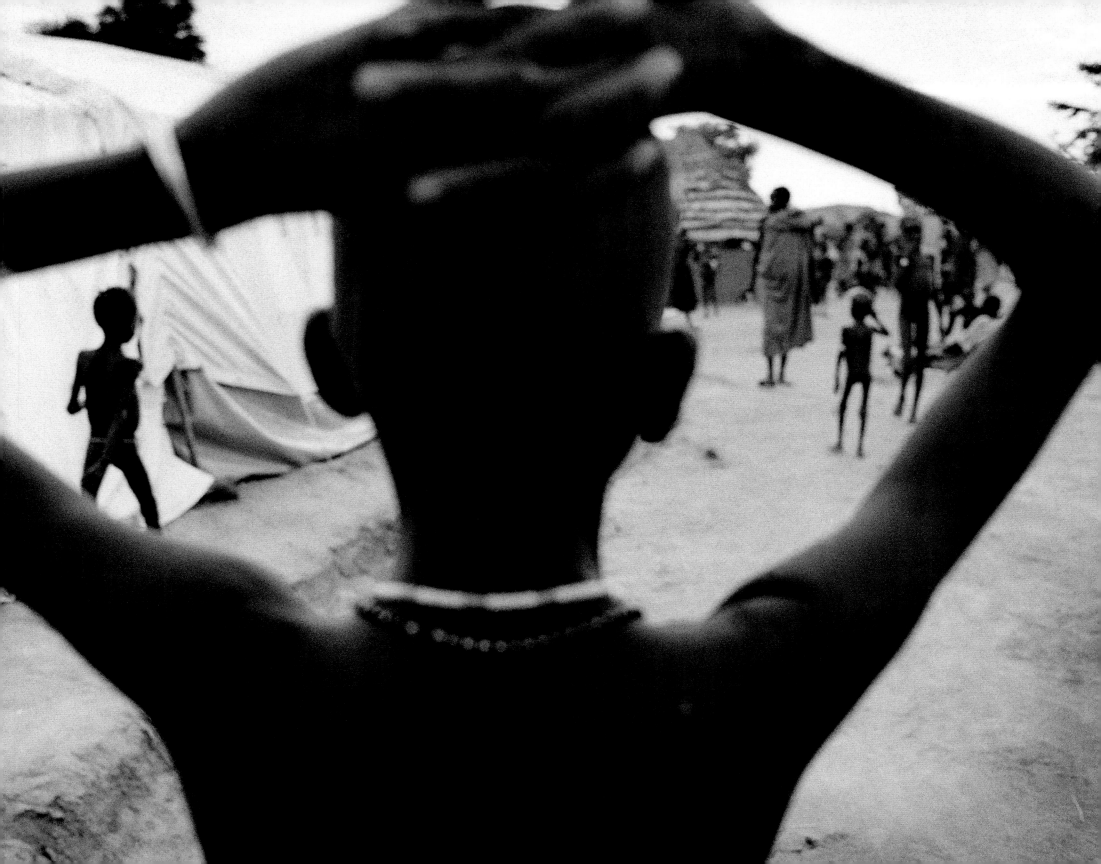

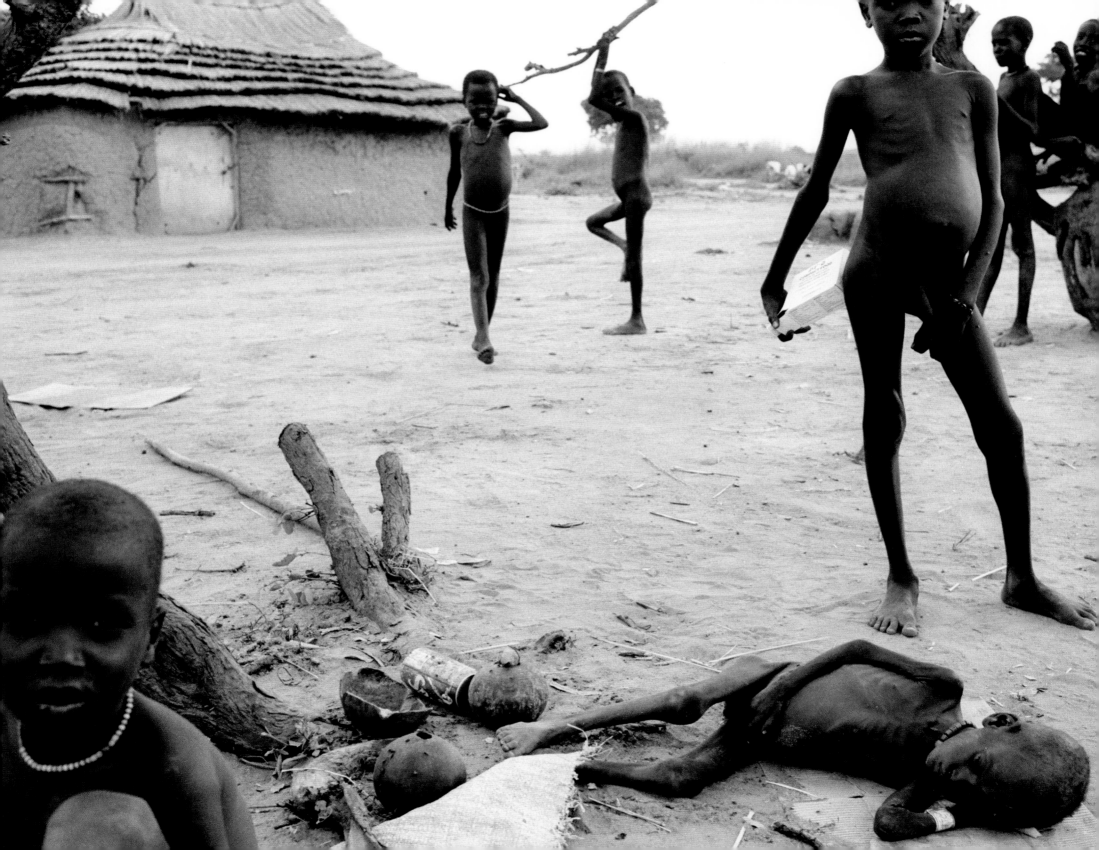

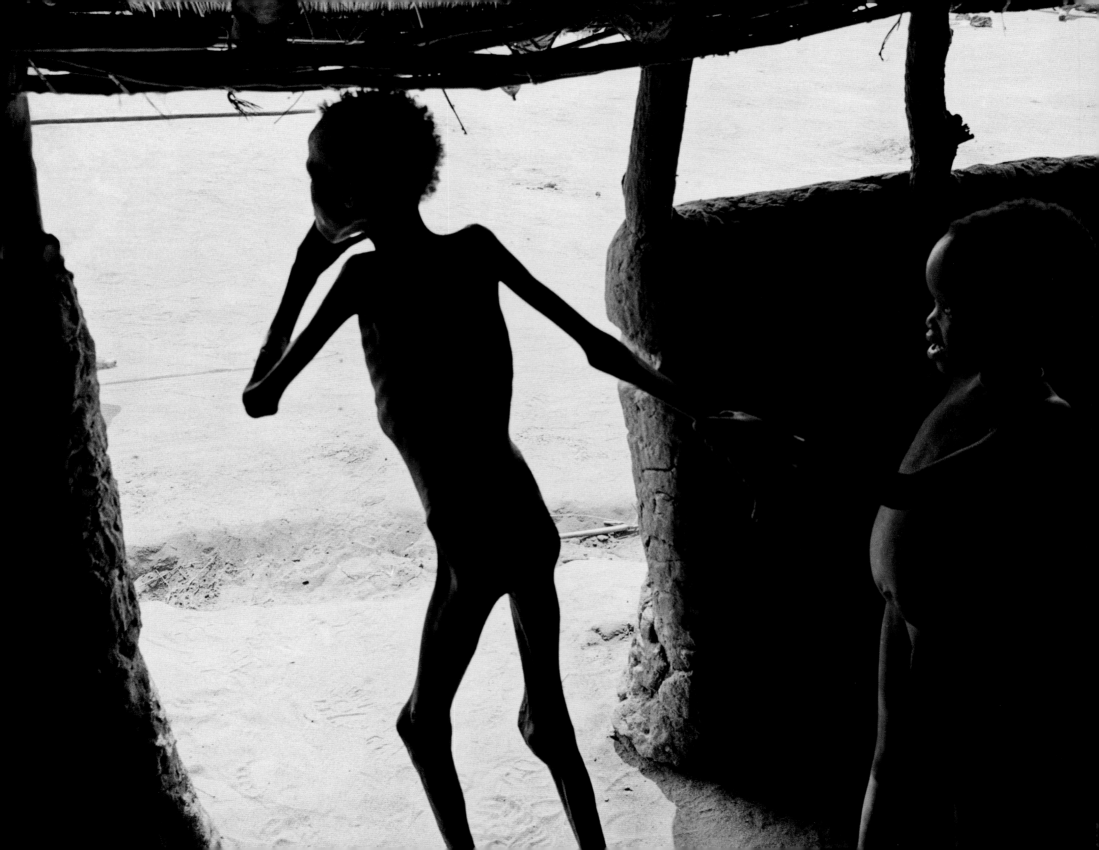

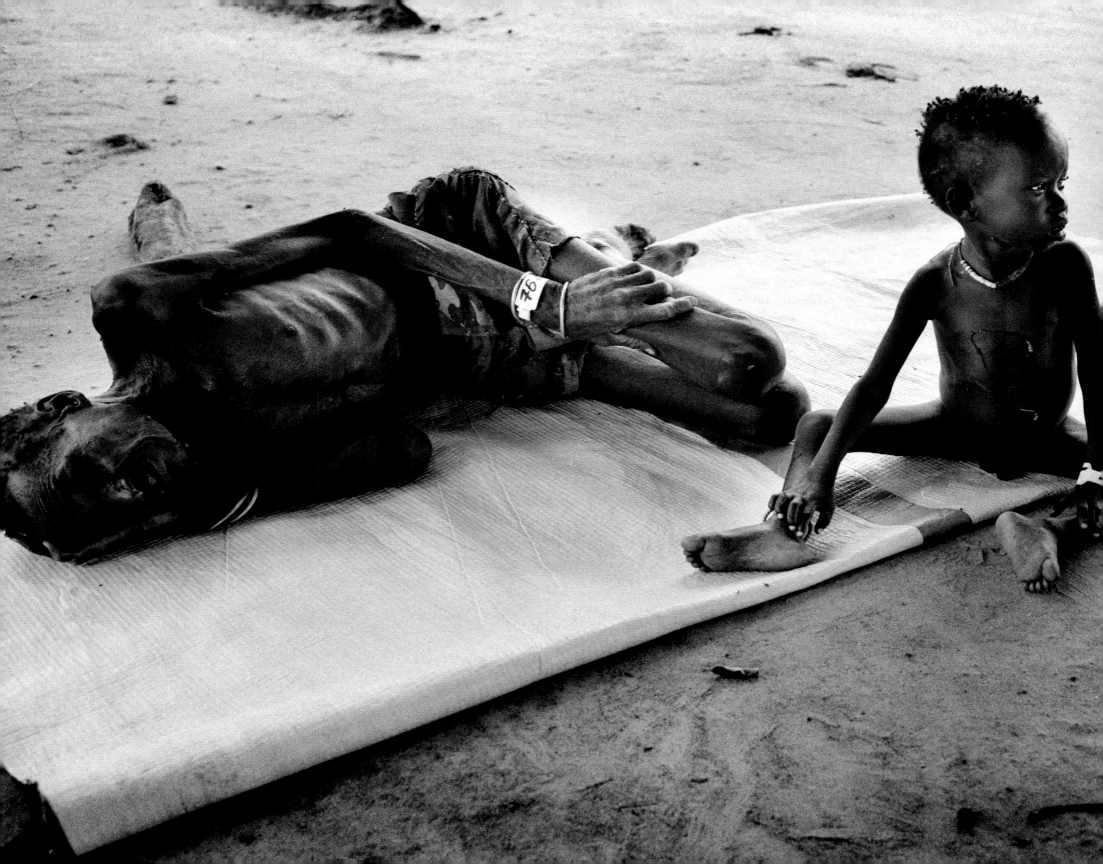

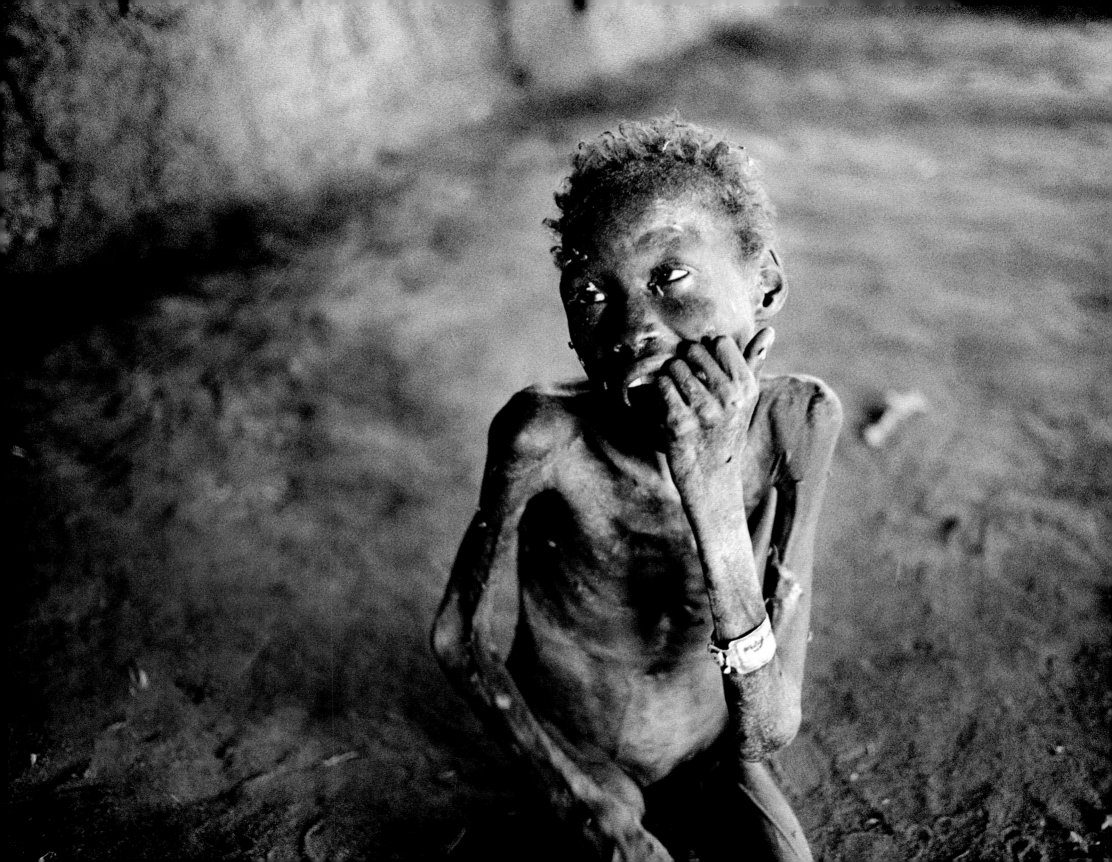

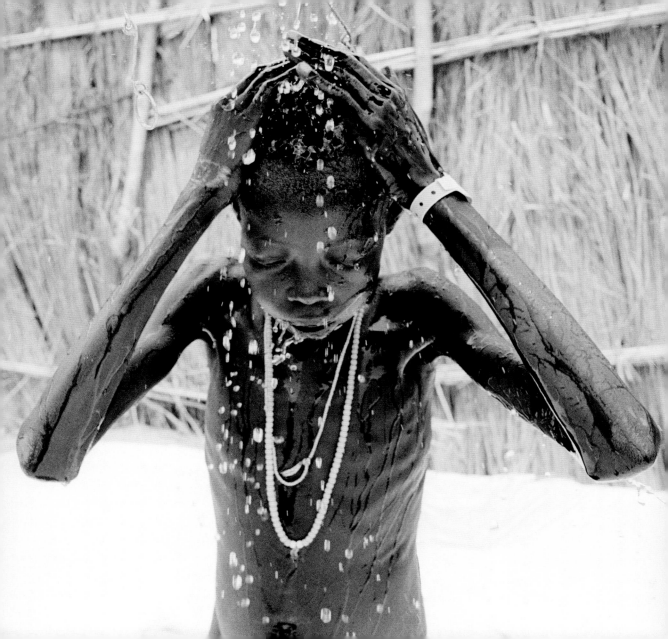

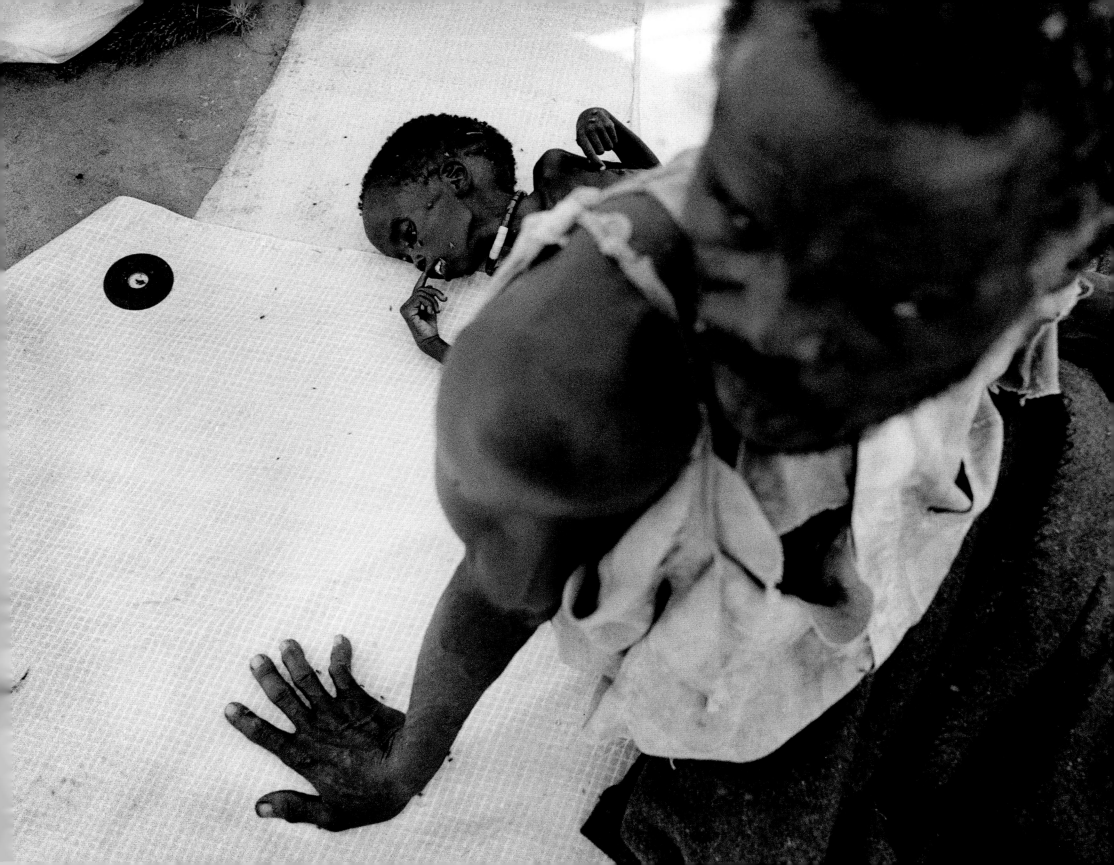

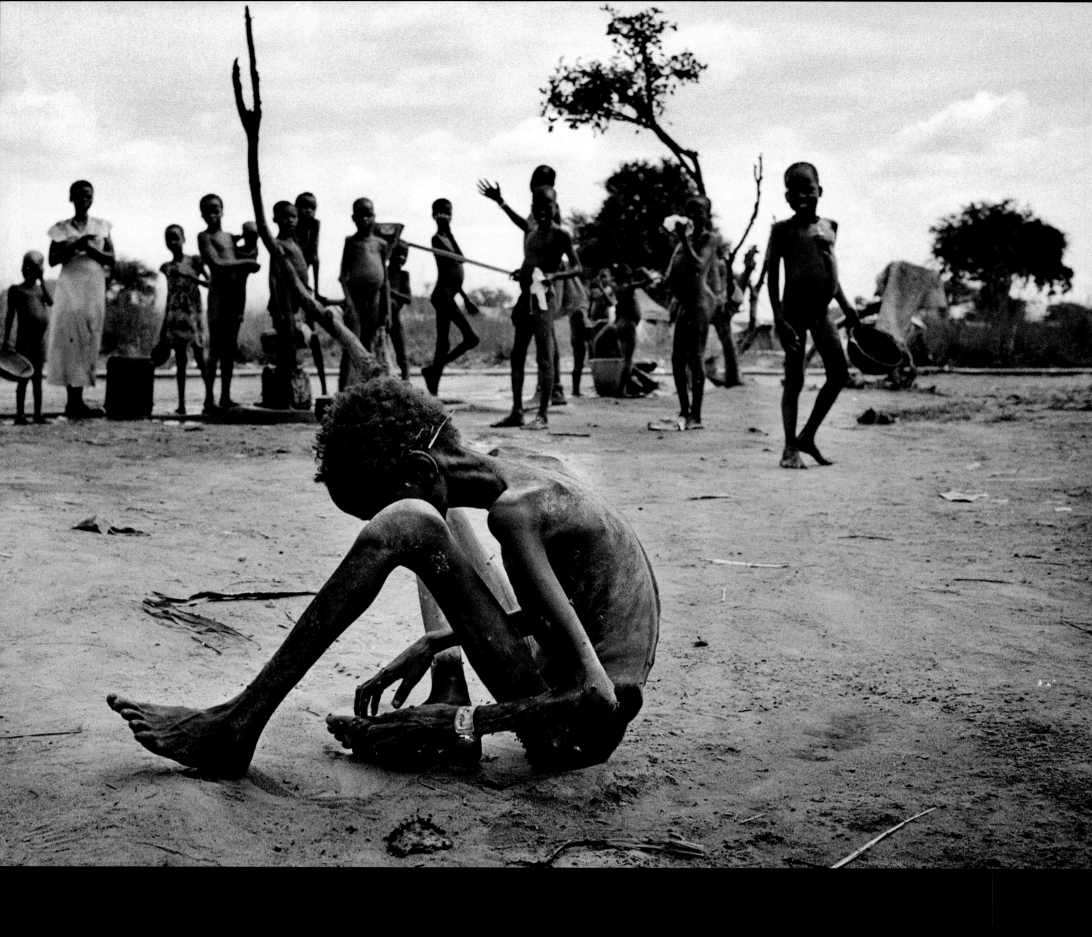

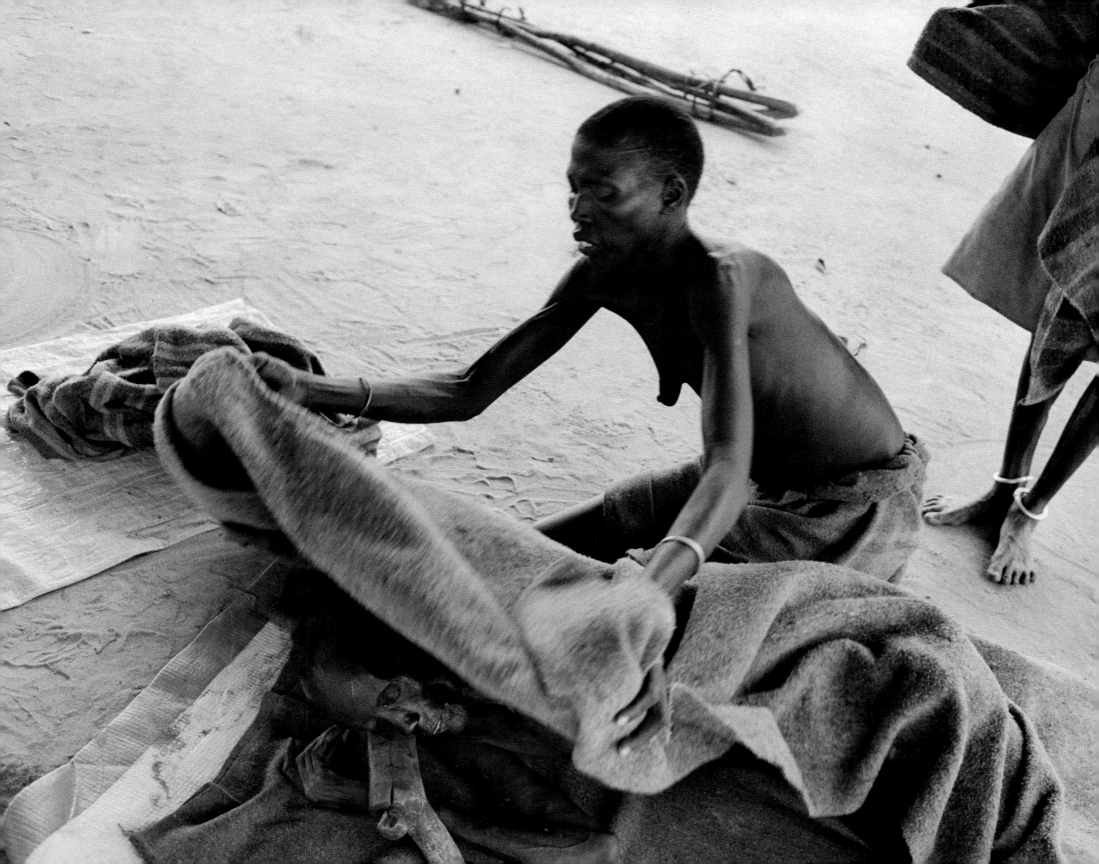

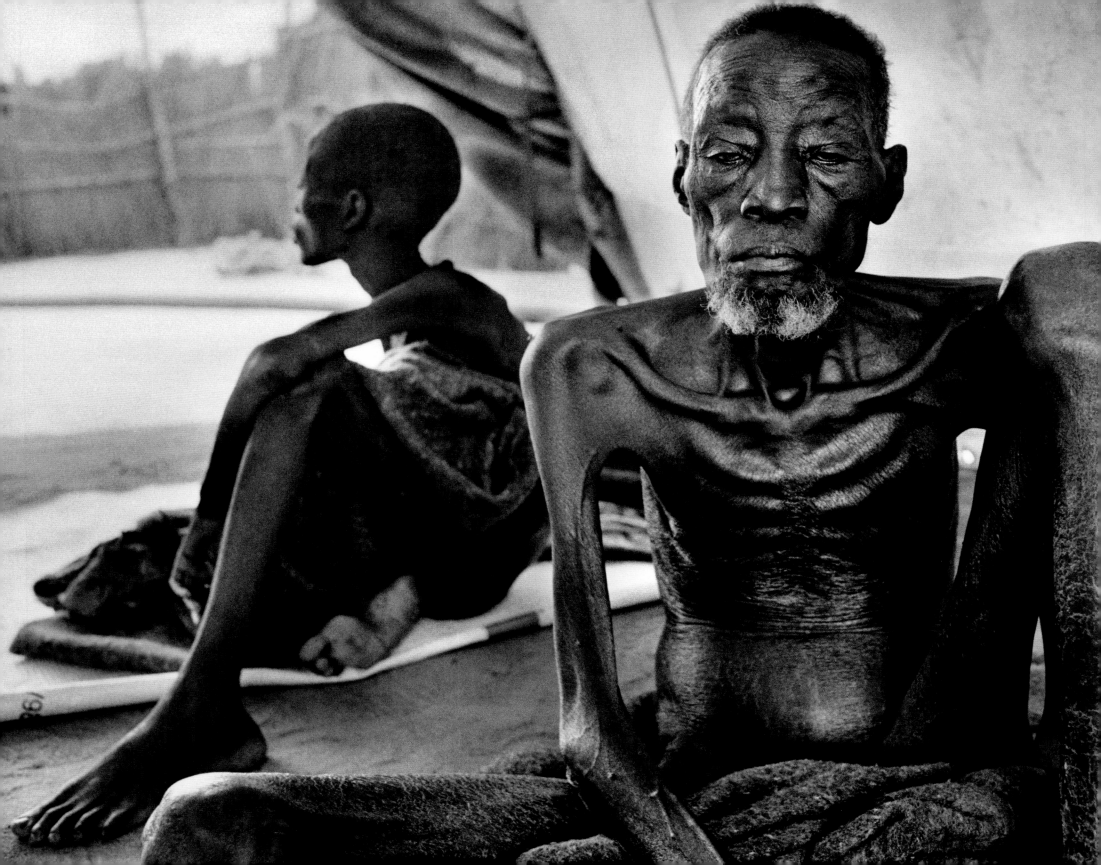

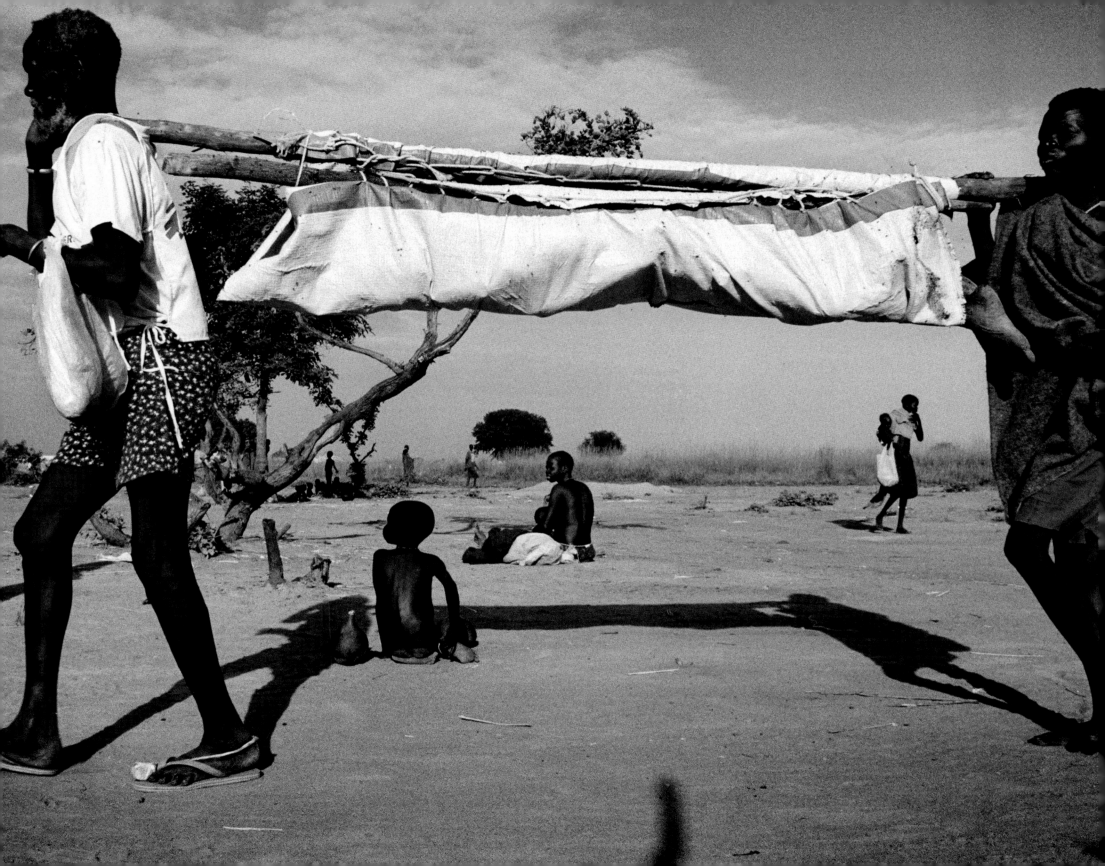

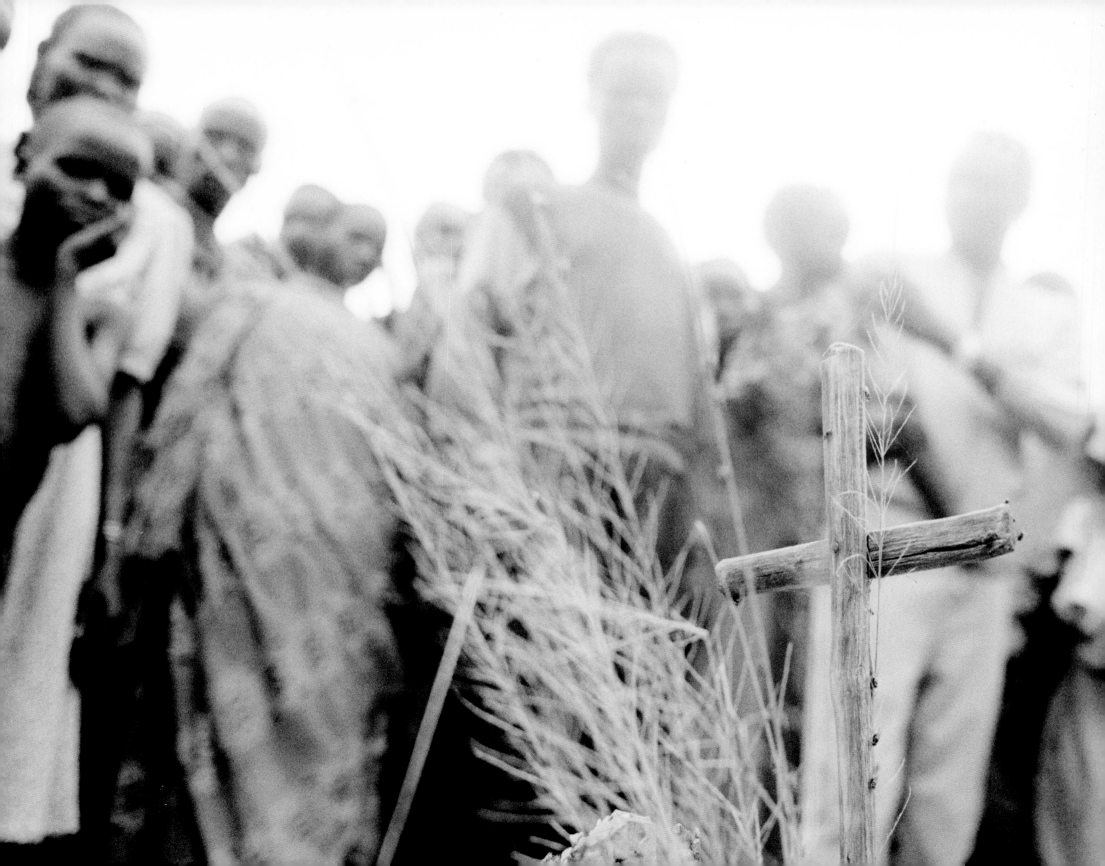

Now:
2001 to Present

If Not Now, When?
Nicholas D. Kristof

Perhaps the most extraordinary aspect of Darfur isn't that gunmen on the Sudanese payroll heave babies into bonfires as they shout epithets against blacks. It's that the rest of us are responding only with averted eyes and polite tut-tutting.

During the last week of October 2006 alone, Sudan expelled the U.N. envoy for Sudan and sent a proxy army to invade eastern Chad. Those moves underscored both the audacity of Sudan's leaders and the fecklessness of the rest of the world's.

In fact, there's plenty we can do. The international community has focused on getting U.N. peacekeepers into Darfur, but Sudan refuses to admit them. The stalemate drags on; the slaughter continues—but here's what we can do:

• Kofi Annan should appoint a new U.N. envoy of utmost prominence. Possibilities include Bill Clinton, Jimmy Carter, Richard Holbrooke, or Bernard Kouchner (a founder of Doctors Without Borders). The envoy's job would be to lead an intensive negotiation aimed at achieving a political settlement.

"This is distracting from the main need," Mudawi Ibrahim Adam, a Sudanese human rights campaigner, said of the focus on peacekeepers. In the long run only a peace accord can calm Darfur. In May 2006, a peace agreement was stillborn after only one Darfur rebel faction signed it, but the pact can be renegotiated, for the differences are small and bridgeable.

• President Bush and European leaders need to use their leverage on four nations in particular to make them part of the solution: China, Saudi Arabia, Egypt, and Libya. China is playing a disgraceful role underwriting the Darfur genocide, by giving Sudan the guns used to shoot children and by protecting Sudan in the U.N. Security Council. And the three Arab states need to be involved so that Sudan cannot claim that plans to protect Darfuris are American or Jewish plots to dismember the country.

"It is very clear there is a plan to redraw the region," the Sudanese president, Omar Hassan al-Bashir, said last month, explaining the calls for U.N. peacekeepers in Darfur. "Any state in the region should be weakened, dismembered in order to protect the Israelis."

Sudanese journalists say that Mr. Bashir has cleverly used such arguments to portray himself as a nationalist, and as a result is in a stronger position now than when he started killing babies in Darfur. Arab leaders need to show that they care about Muslim children being shot even when Israel is not responsible.

• To get more coverage on Al Jazeera and other Arab networks, Mr. Annan could take a planeload of Arab journalists on a visit to Darfur refugee camps. Condoleezza Rice could do the same. The U.S. could put video footage (I'd supply some) of Darfur atrocities on its Arabic-language satellite television station, Al Hurra.

• The U.S., France, and U.N. should immediately send peacekeepers to Chad and the Central African Republic to prop up those countries (the U.S. can supply airlift, intelligence, and communications support, but our ground troops would create a backlash). Sudan has sent proxy forces to invade both, and they are teetering.

• We need contingency plans for forcible military intervention. There is talk that in the coming months Sudan's janjaweed militias may start systematically massacring some of the 2 million people who have taken shelter in camps in Darfur. If that were to happen, U.N. and NATO forces would have to go in and rescue those people—and if Sudan knew of such contingency plans, that would make massacres less likely.

• The U.S. and French air forces should jointly impose a no-fly zone from the French air base in Abéché, Chad, as the Chadian president has invited them to do.

• Western countries should apply targeted sanctions that freeze international assets of Sudanese leaders whom the U.N. has already listed as involved in the genocide.

• Mr. Bush must use his bully pulpit. He could invite Arab and African leaders to the White House for a summit on Darfur. He could suggest to the Chinese president, Hu Jintao, that they jointly visit the area.

After fewer than 10,000 white people died in Kosovo, the U.S. intervened to prevent genocide. So far, several hundred thousand black people have been slaughtered in Darfur, and our president hasn't even dedicated a speech to it.

If we don't try bold new approaches now, when? After 750,000 have died and Chad has collapsed? After all north central Africa is in chaos and 1.5 million are dead? When?

Nicholas Kristof is a *New York Times* writer who has been crucial in bringing the issue of Darfur to public. Copyright © 2007 by The New York Times Co. Reprinted with permission.

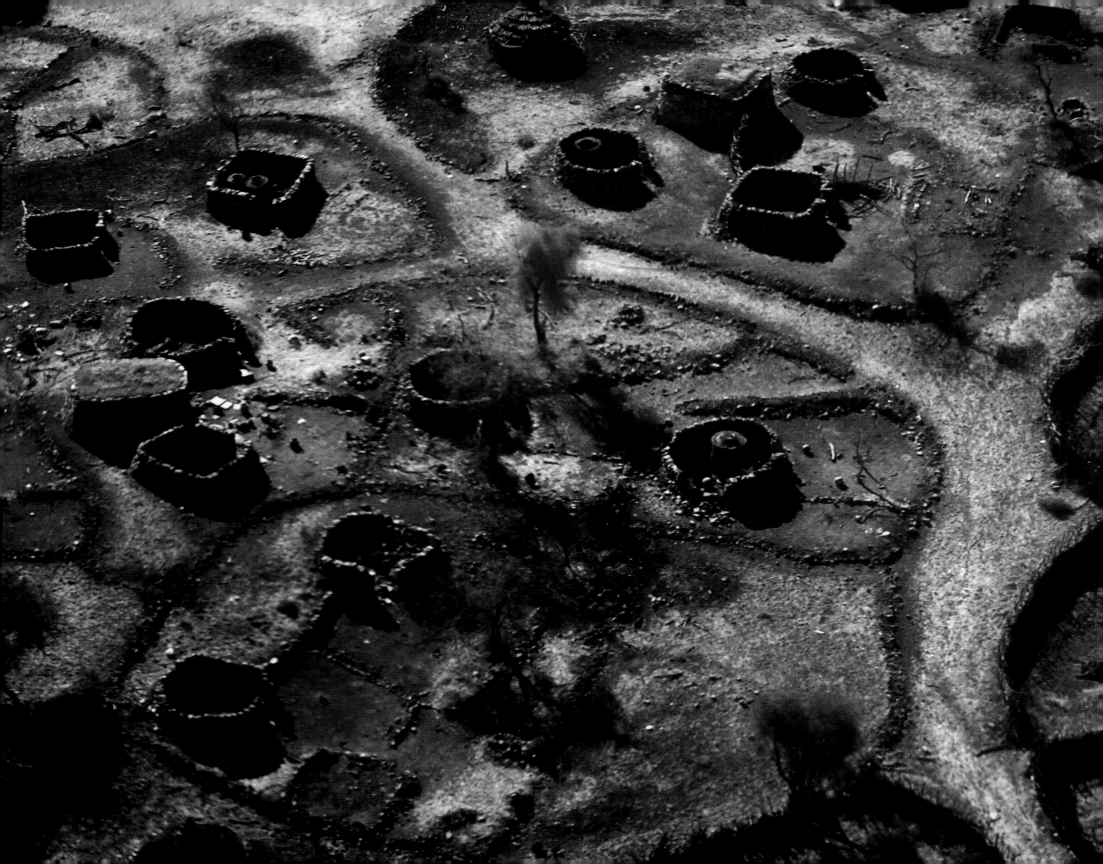

Villages

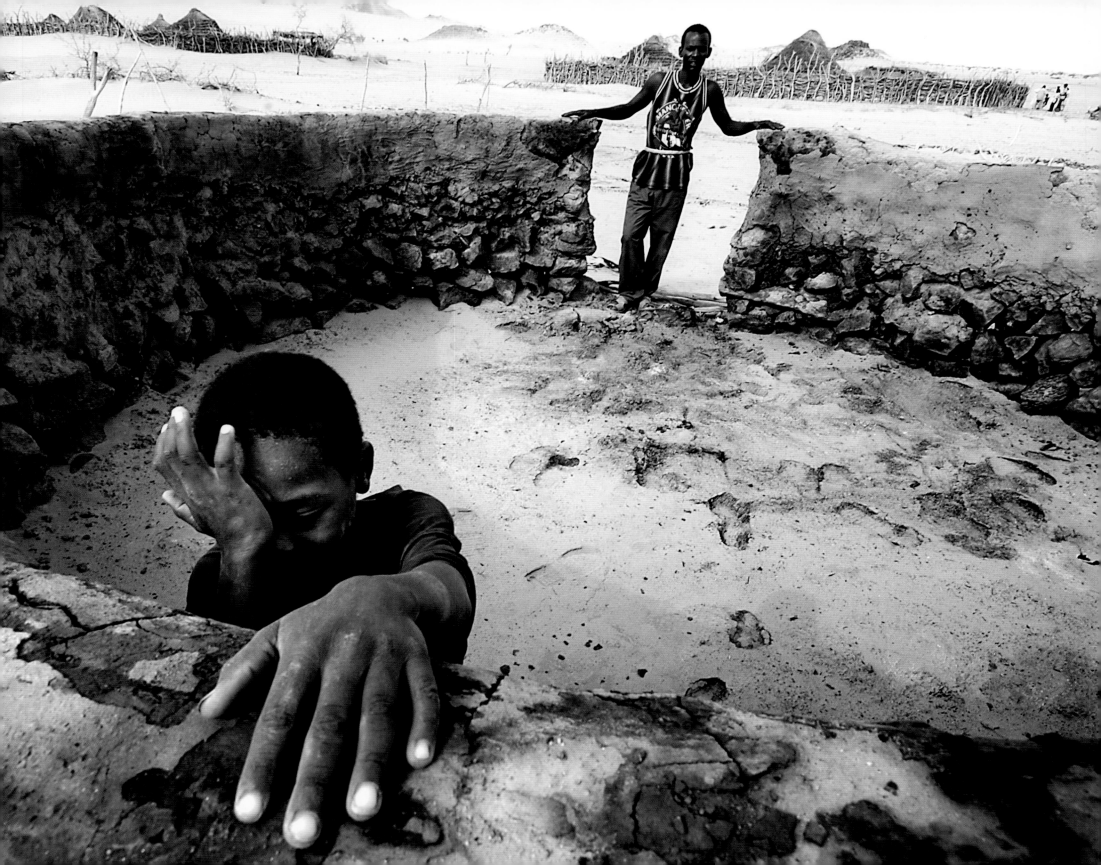

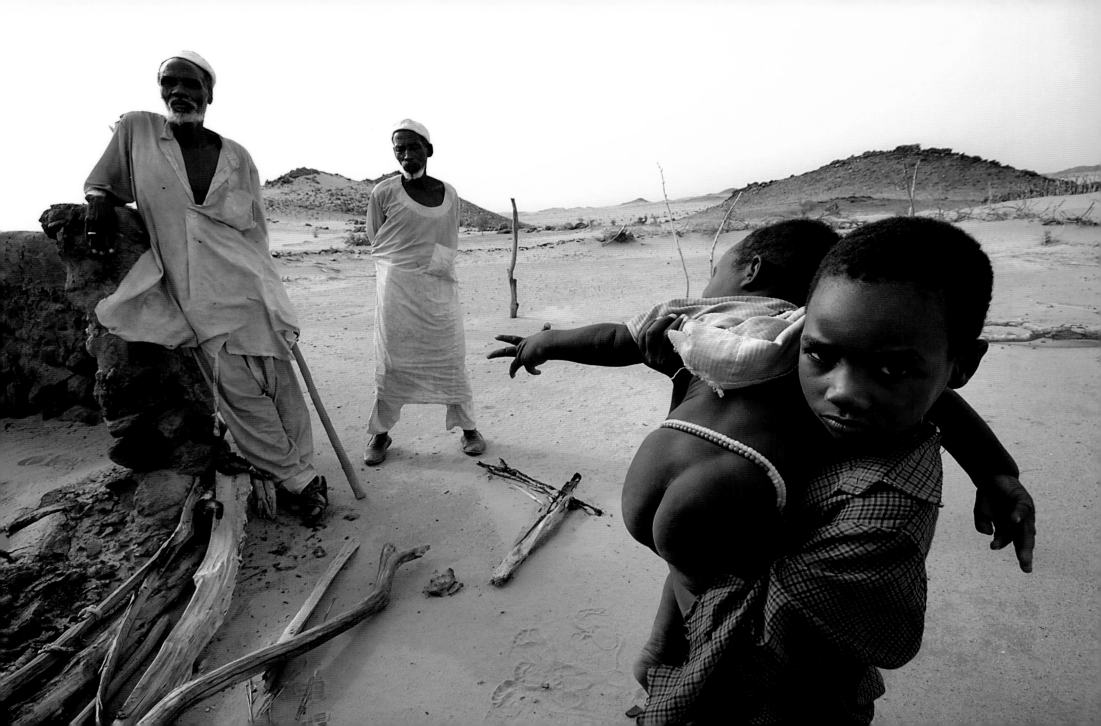

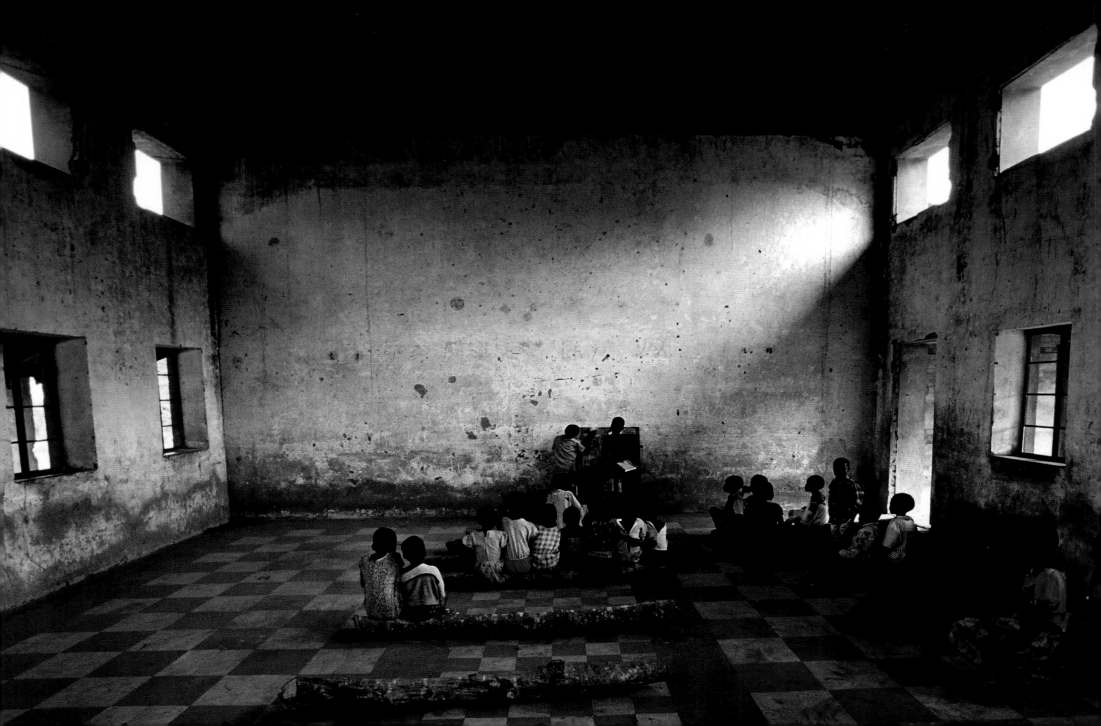

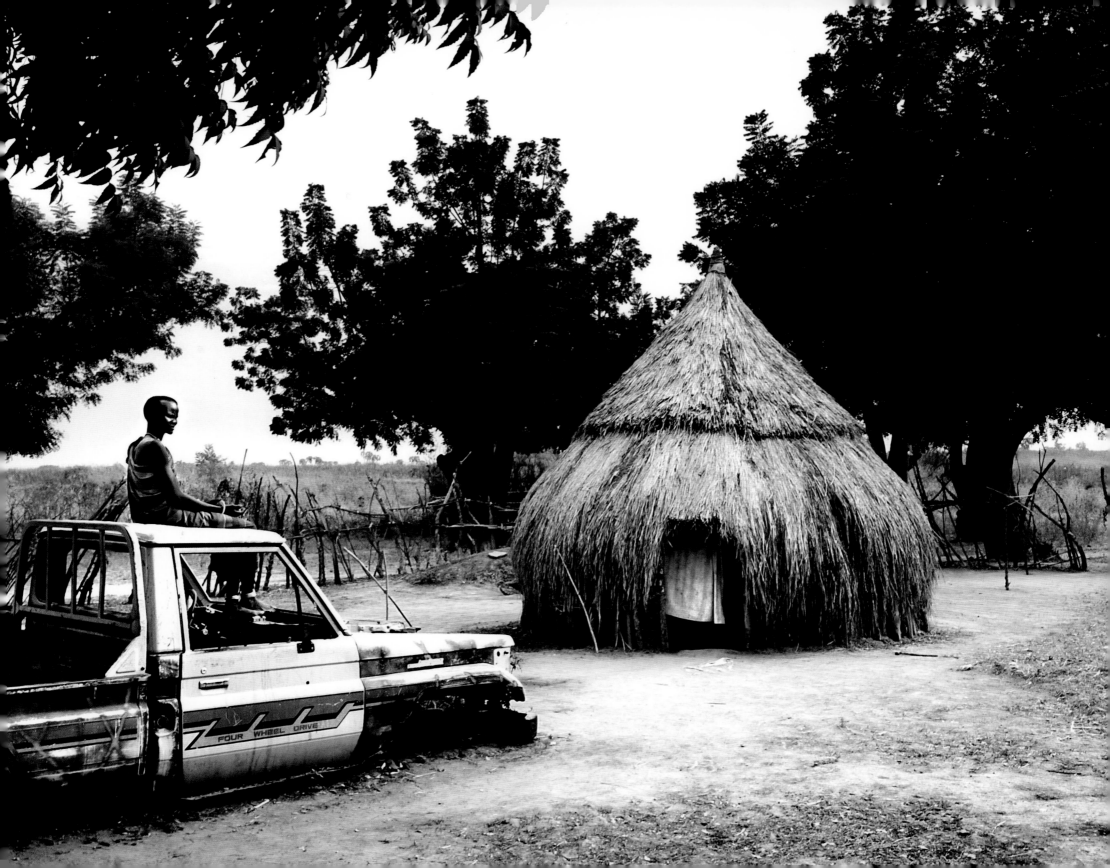

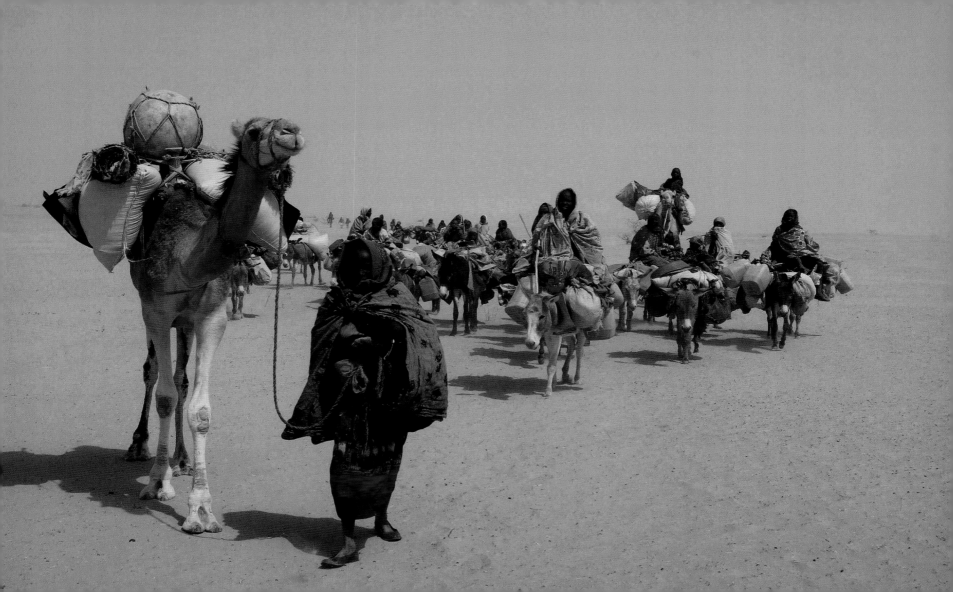

Five men who tried to run away were captured by the janjaweed.... They tied ropes around their necks and then to their horses and then rode their horses back and forth dragging their bodies for five to ten minutes. Blood was pouring out of their mouths and noses. They even whipped them on their heads and bodies with their reins, until they were completely covered in blood.

Testimony of Abdelrahman Sinoussi, describing the killing of five villagers from Koloye

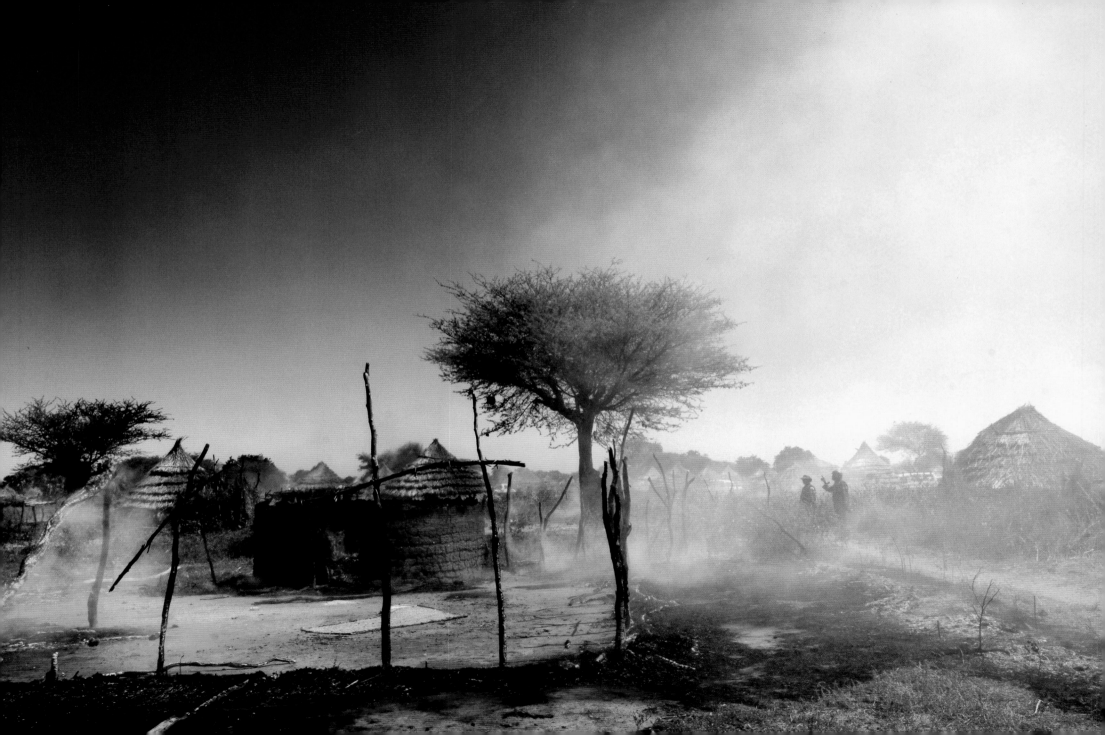

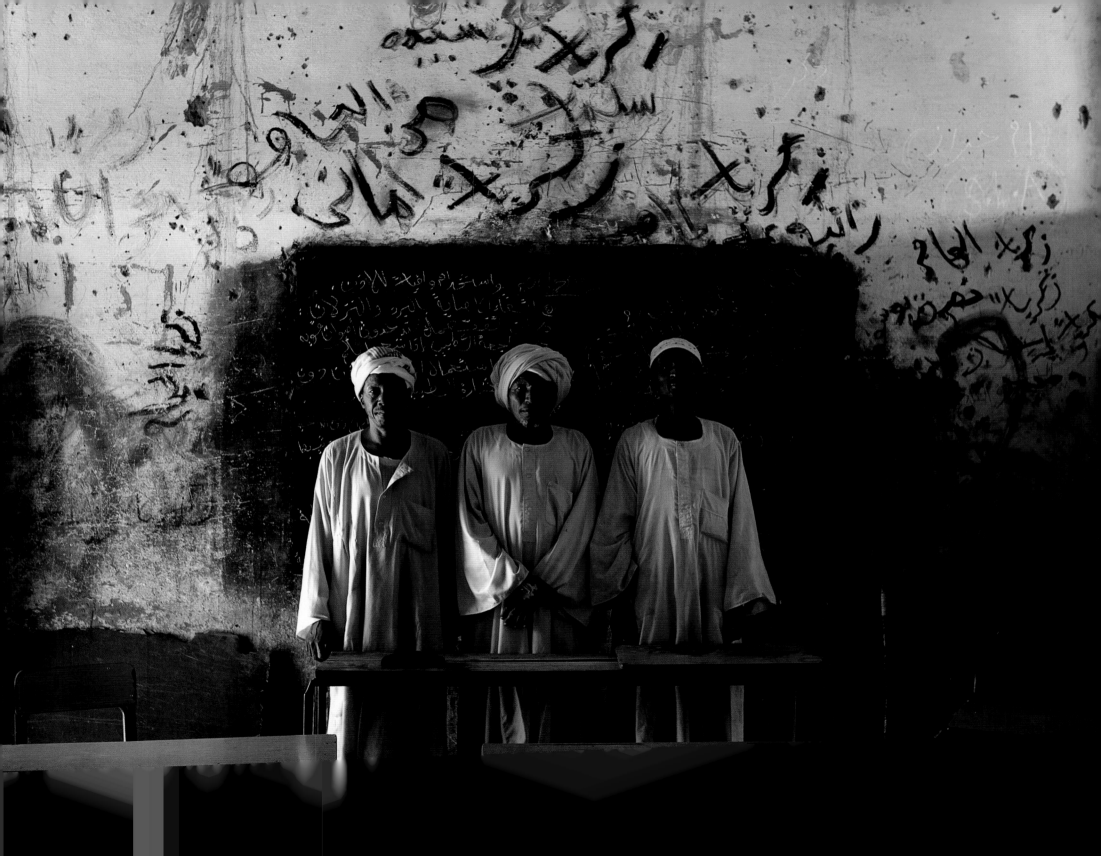

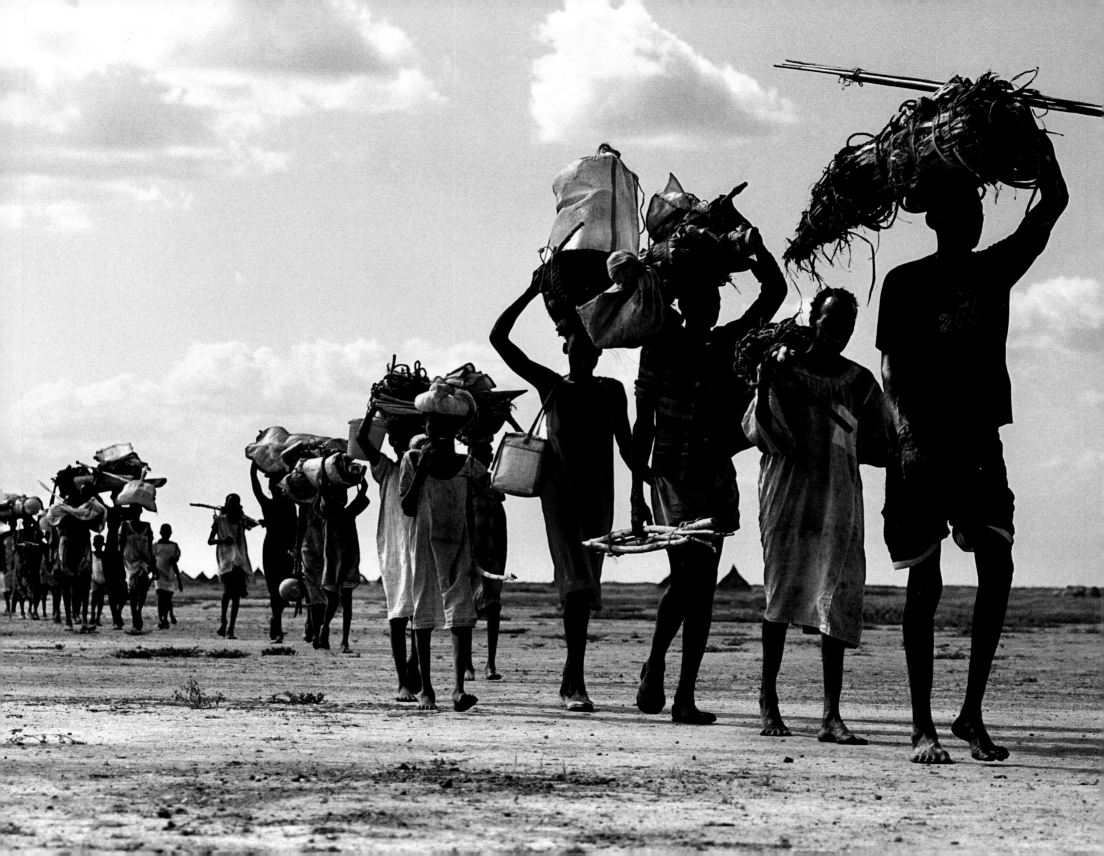

Iraq or Darfur?

Jonathan Alter

The woman was crying, so there wasn't much I could say to rebut her argument. She had lost her son, a U.S. marine, in Iraq. Like many others in such a situation, she was not about to admit that he may have been fighting for the United States in a lost cause.

Amid her tears, the anger was hard to miss. To withdraw from Iraq now would mean her son's death was "pointless," she said, and she could never accept that. "So we need to stay to 'finish the job,' at any cost?" I asked. "Whatever it takes," she said. Her fury boiling over, she complained bitterly about all of the money going to "Derfor, or however you pronounce it. That money," she said, "should be used in Iraq."

It's always tricky predicting how historians will judge an era, but I'd bet they will come to the exact opposite conclusion. They'll look back and say, "If it weren't for Iraq, the crisis in Darfur might have received more attention at the turn of the 21st century. If it weren't for Iraq, millions of people thousands of miles away would have been saved from persecution and death." That's a heavy load emotionally, but one we should be prepared to bear.

The numbers tell the story: We are in the process of committing hundreds of billions of dollars to the Iraq War, with the Baker-Hamilton Commission endorsing estimates of $2 trillion in eventual costs. By contrast, a bill to approve $40 million to prod the African Union toward intervention in Darfur stalled in the Republican-controlled Congress in 2006.

Even as the money loosens up, it will be a pittance compared to what the United States spends in Iraq. If spending on Darfur eventually amounts to even 1 percent of Iraq expenditures, it will be counted as a huge victory for those seeking to raise consciousness about genocide in Africa.

Economists like to talk about "opportunity costs"—the money we lose by being tied up in one thing instead of being free to take part in something else. The "opportunity costs" of the Iraq war are vast. Think of the mouths that could have been fed and diseases cured in the developing world with the money being spent in Iraq. It would have made even Bill Gates seem like a piker. But perhaps the greatest opportunity cost of all is in Sudan and Chad. With at least 400,000 dead and millions driven from their homes, the "opportunity cost" could have been in murders prevented. To the more than 3,000 Americans and hundreds of thousands of Iraqi civilians who have died, we must add the blood of Darfur. While the janjaweed, sponsored by the Sudan government, deserve primary blame, the rest of us—the people who are letting the massacre happen—deserve our share.

From the beginning, the Bush Administration has been clear-eyed about the nature of the conflict in the Sudan. The president himself has repeatedly referred to it as a "genocide." Only a decade removed from genocide in Rwanda, and all of the promises of "never again" have been forgotten.

So why have they? Because Iraq has sucked up all of the oxygen in the global community. The best intentions and most heightened sense of idealism cannot compete with the gaping wound at the juncture of the Tigris and Euphrates.

The most frequently offered explanation is that the stakes are simply much higher in the Middle East than in Africa. However this is an illusion: the janjaweed are Arabs, and the area is crawling with Islamic fundamentalists bent on harming the United States. The 1998 embassy bombings in Nairobi and Dar es Salaam showed that terrorism has a serious foothold on the continent. Making the distinction between the Middle East and Africa lacks moral content, a barren and cynical basis for a foreign policy that is supposed to reflect American values. Worse, such distinctions suggest some kind of argument or debate, when in fact there has been none.

No one has raised the issue about Iraq or Darfur directly. They are seen as separate situations, separate nation-states. Only a foreign policy naïf, we're told, would try to conflate them. And yet in the real world of budgets and short foreign policy attention spans, they are hopelessly conflated already. How else to explain why the U.S. government says so many of the right things, and does so few of them?

Imagine a world where the Iraq war had never happened. Would the United States be doing more to bring about peace and justice in Darfur? Almost certainly yes. And the son of the woman I was interviewing would still be alive.

Jon Alter is a journalist for *Newsweek* and *NBC News*.

Who Is Selling Arms to Sudan?

Military aircraft and parts: *China, Belarus, Lithuania*
Tanks, military vehicles, and artillery: *Belarus, Russia, Poland*
Grenades, guns, and ammunition: *China, France, Iran, Saudia Arabia*

A Hard Look at the Facts

Amount the Sudanese government spent on weapons in 2003: *$18 million*

Average number of guns per janjaweed militiaman: *5 to 6*

Factor by which arms and ammunition exports to Sudan from China increased between 2000 and 2003: *30*

U.N. Permanent Security Council members who are major suppliers of arms to Sudan: *3 (China, Russia, and France)*

Estimated number of people in Darfur who have been killed or died as a result of the conflict: *400,000*

Number of people in Darfur currently living in camps or makeshift settlements: *2 million*

Number of Sudanese who have fled to Chad because of continuing violence: *215,000*

Number of Sudanese dependent on humanitarian aid for food, shelter, and medicine: *3.5 million*

Number of Darfur refugees blocked from receiving humanitarian aid because of political infighting: *250,000*

Number of Sudanese war criminals prosecuted since March 2005, when the International Criminal Court established a Sudanese war crimes tribunal: *0*

Sources: Amnesty International; United Nations, International Criminal Court

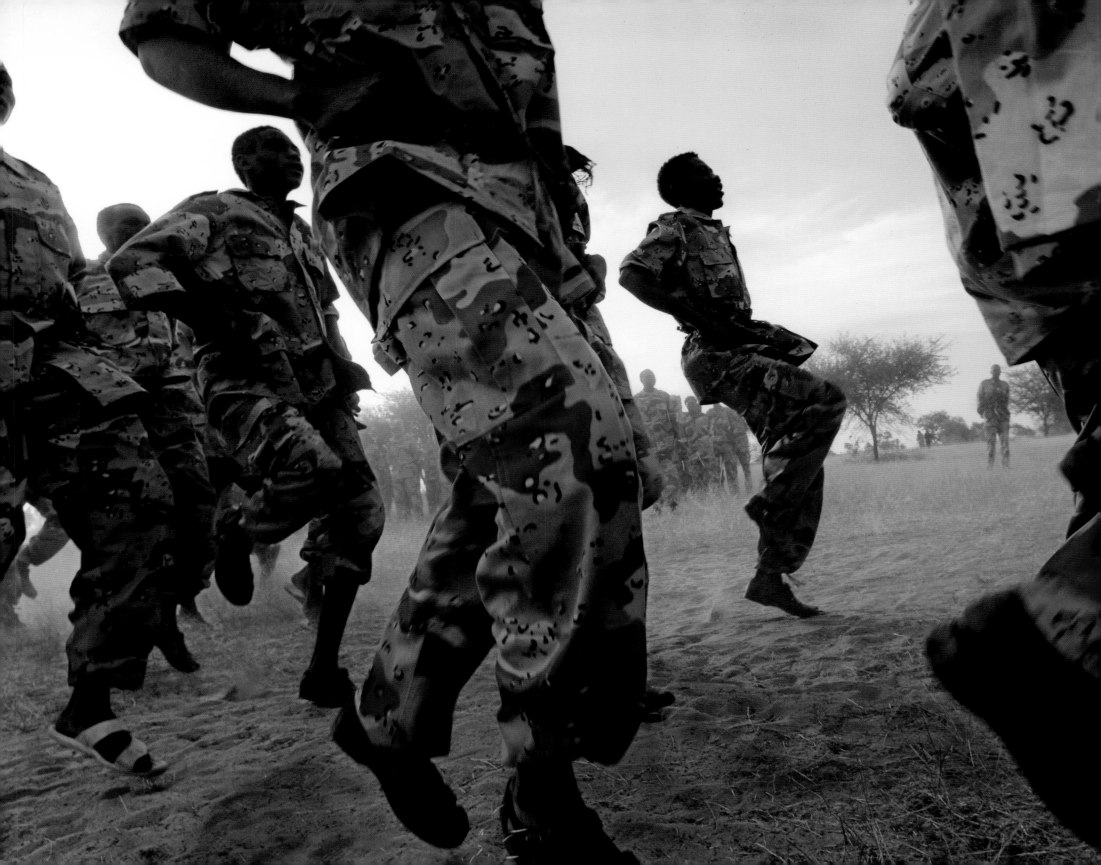

Military

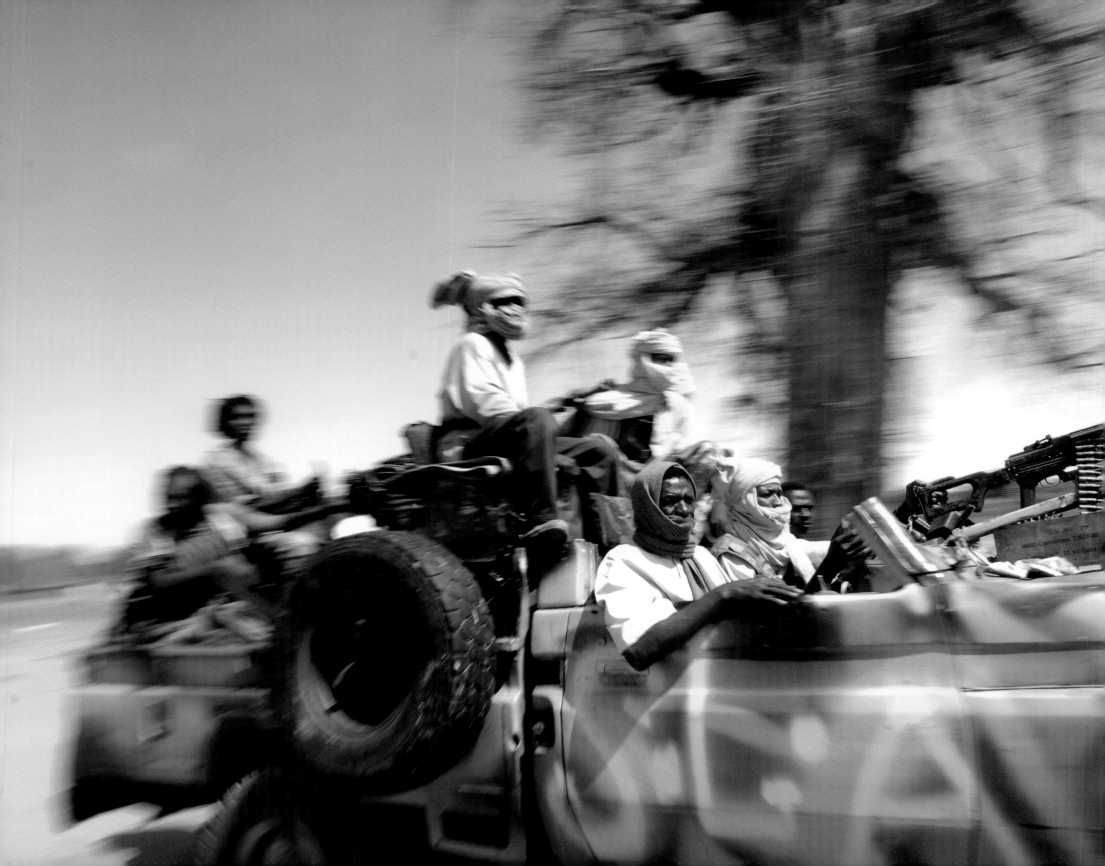

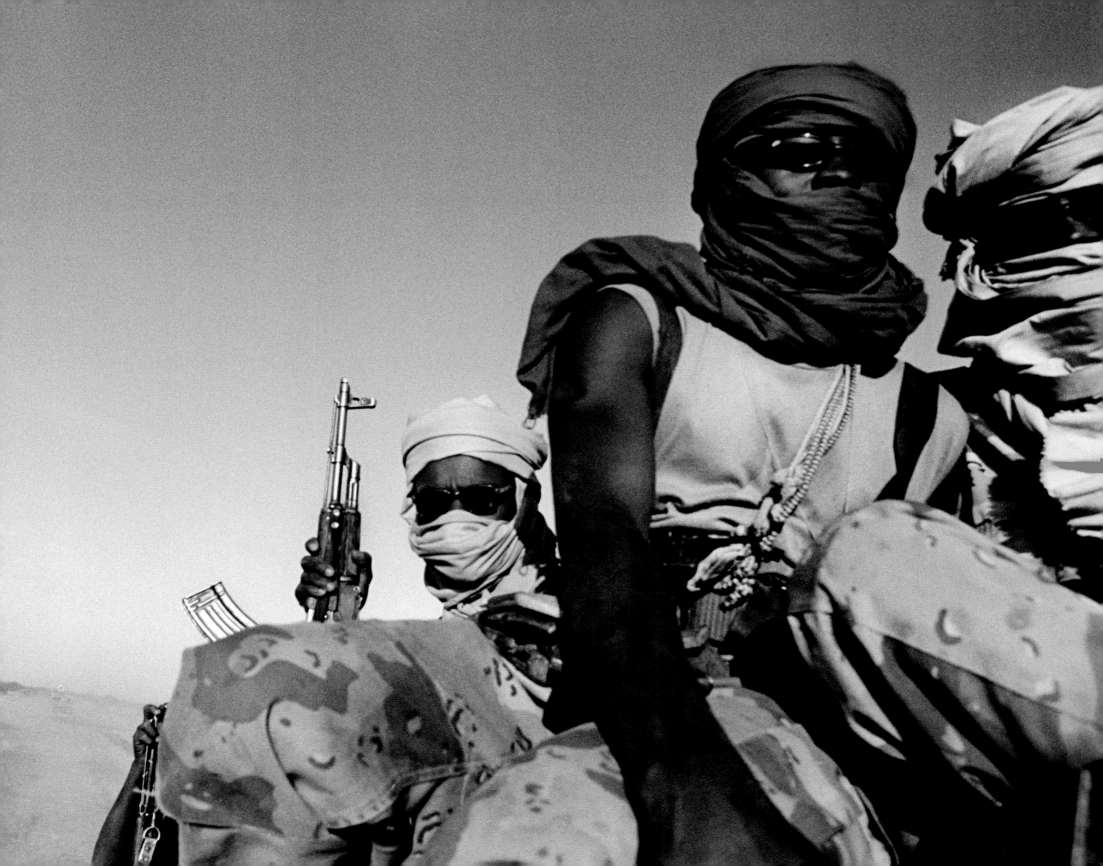

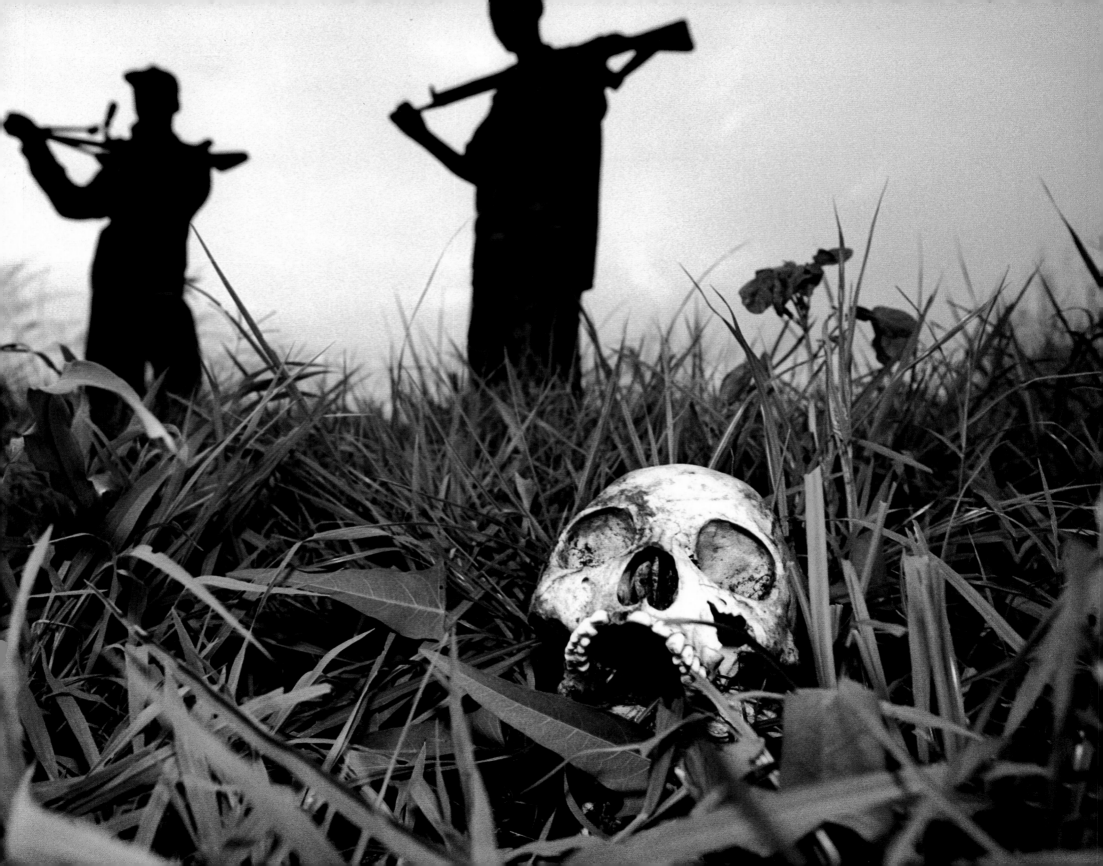

It was early in the morning, people were sleeping. About 400 armed people with military uniforms, the same ones worn by the army, cordoned off the village.... Some were shot and others, such as children and the elderly, were burned alive in their houses.

Anonymous

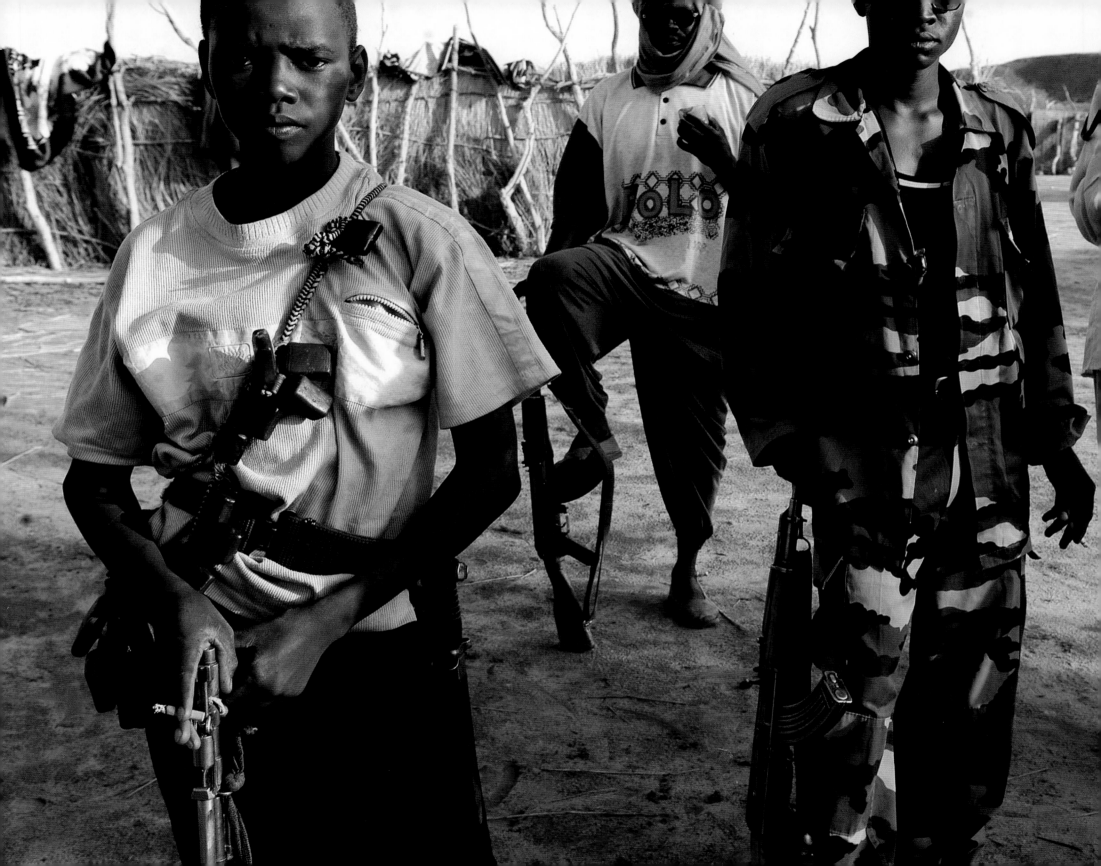

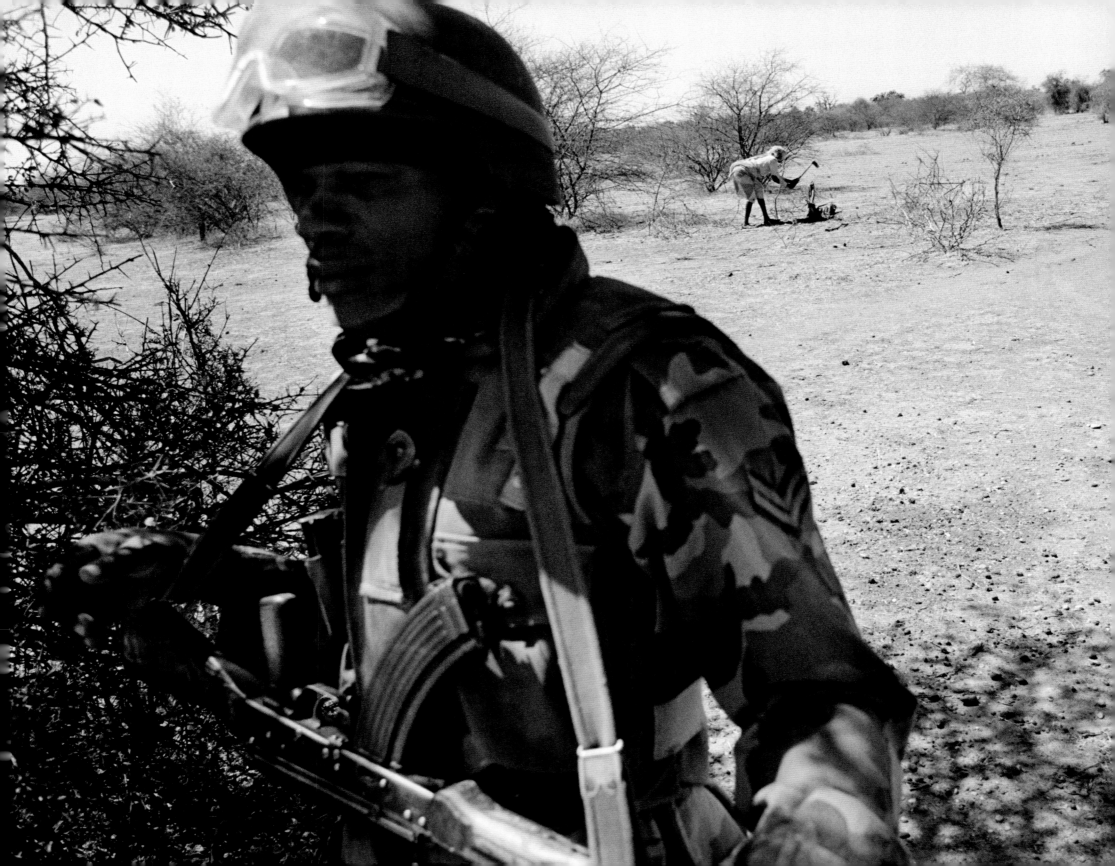

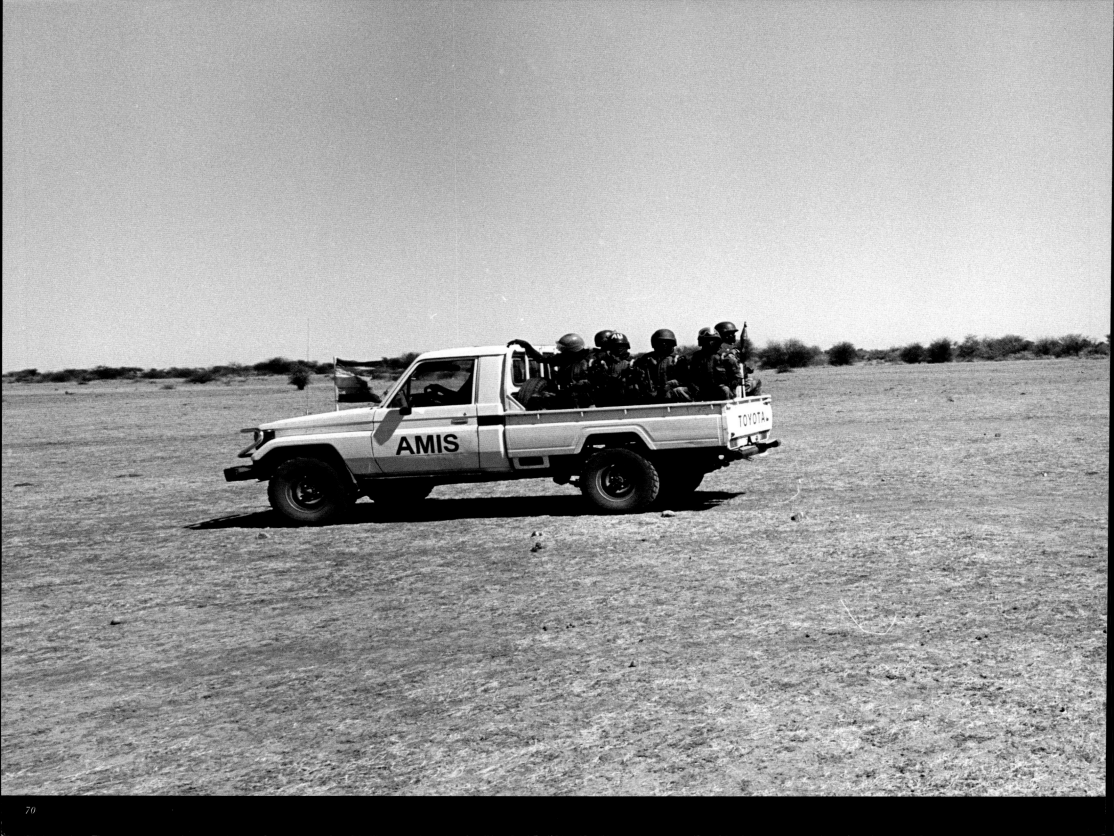

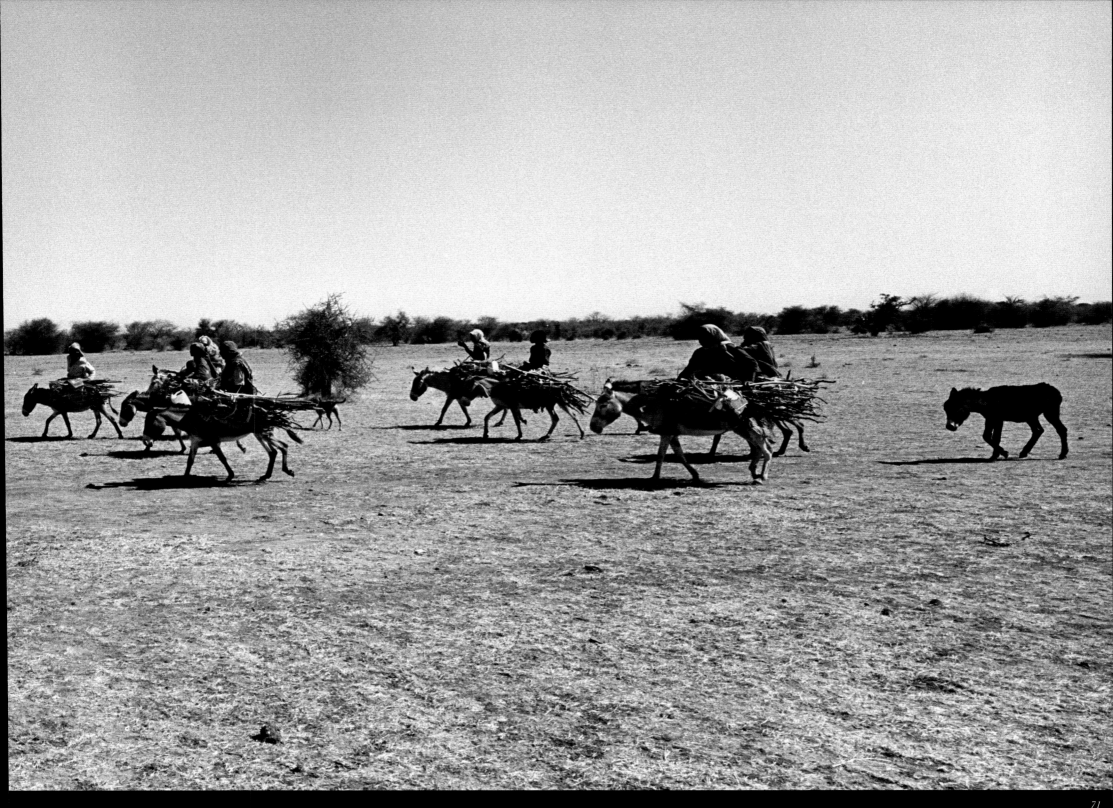

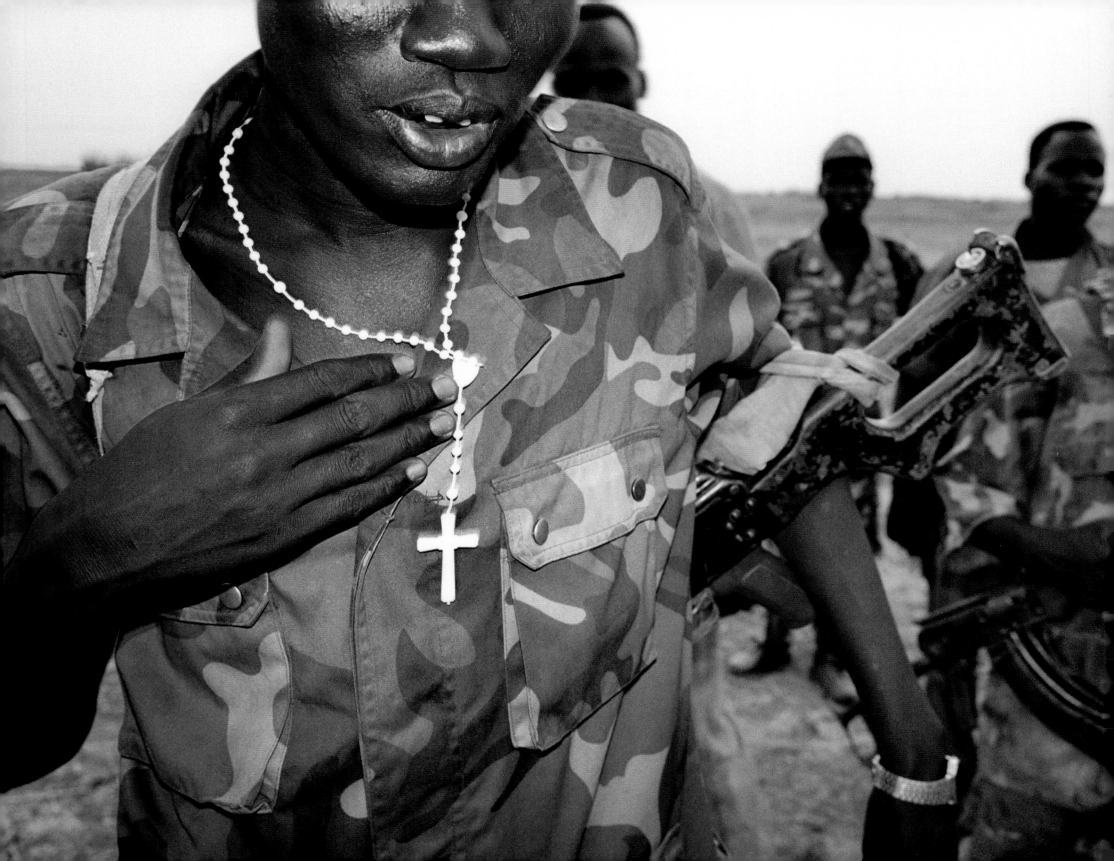

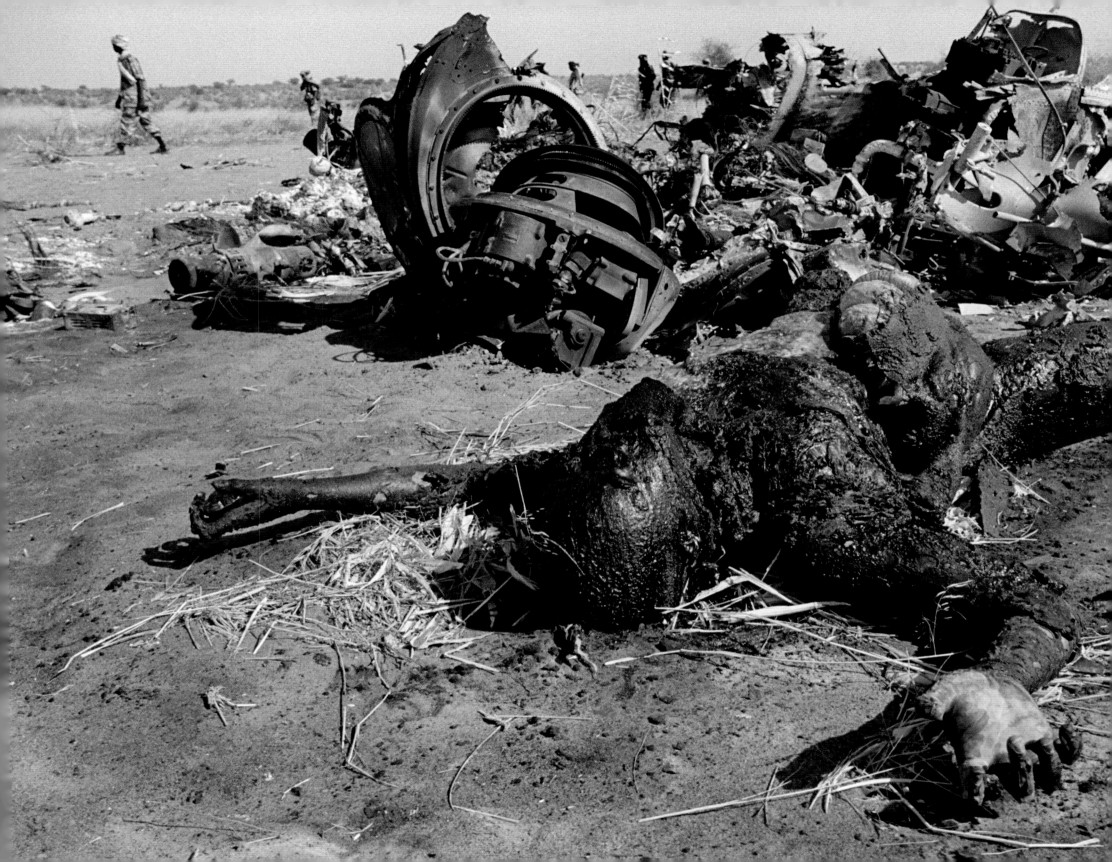

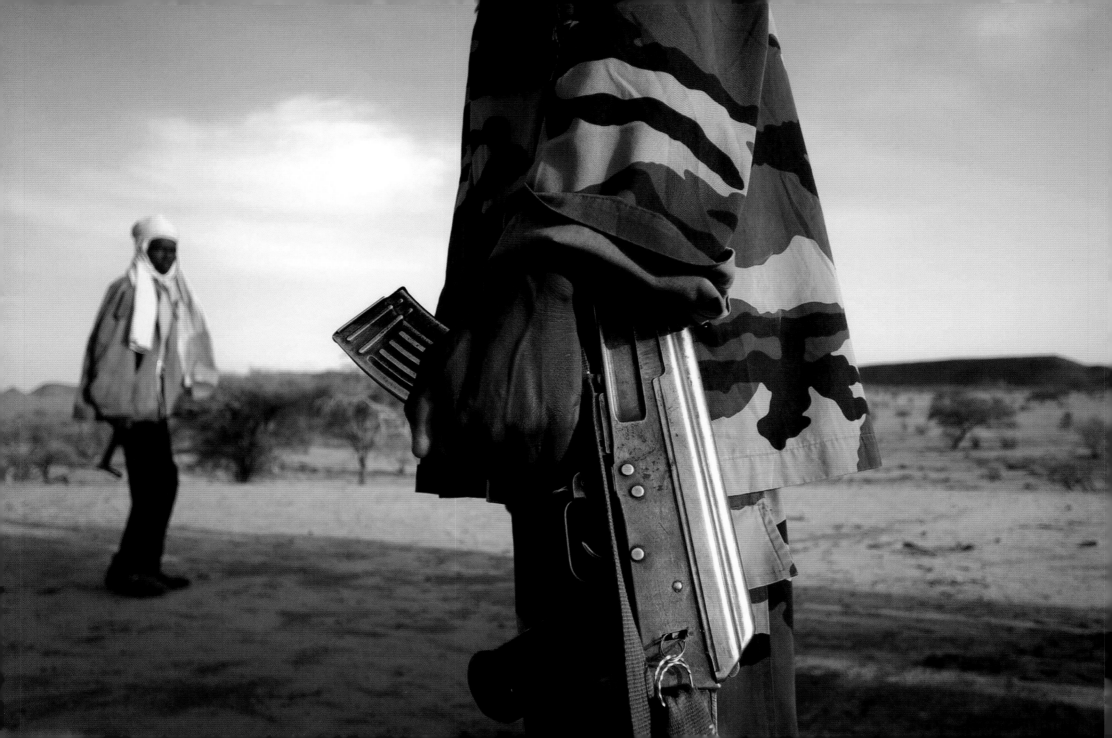

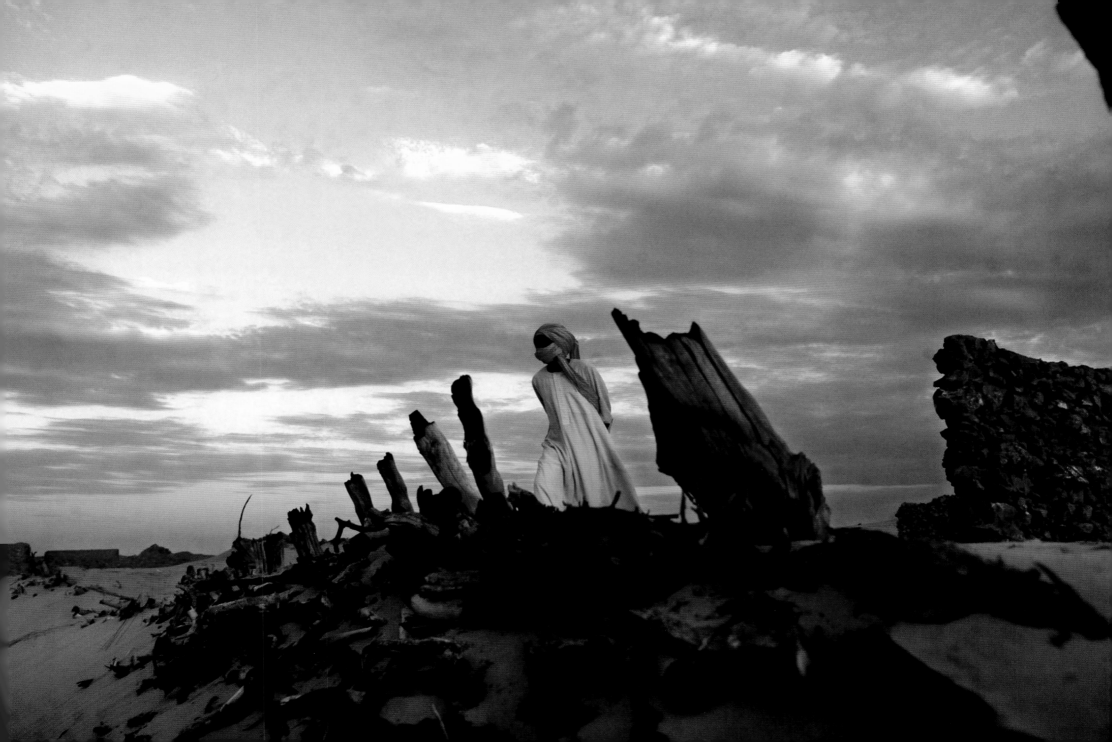

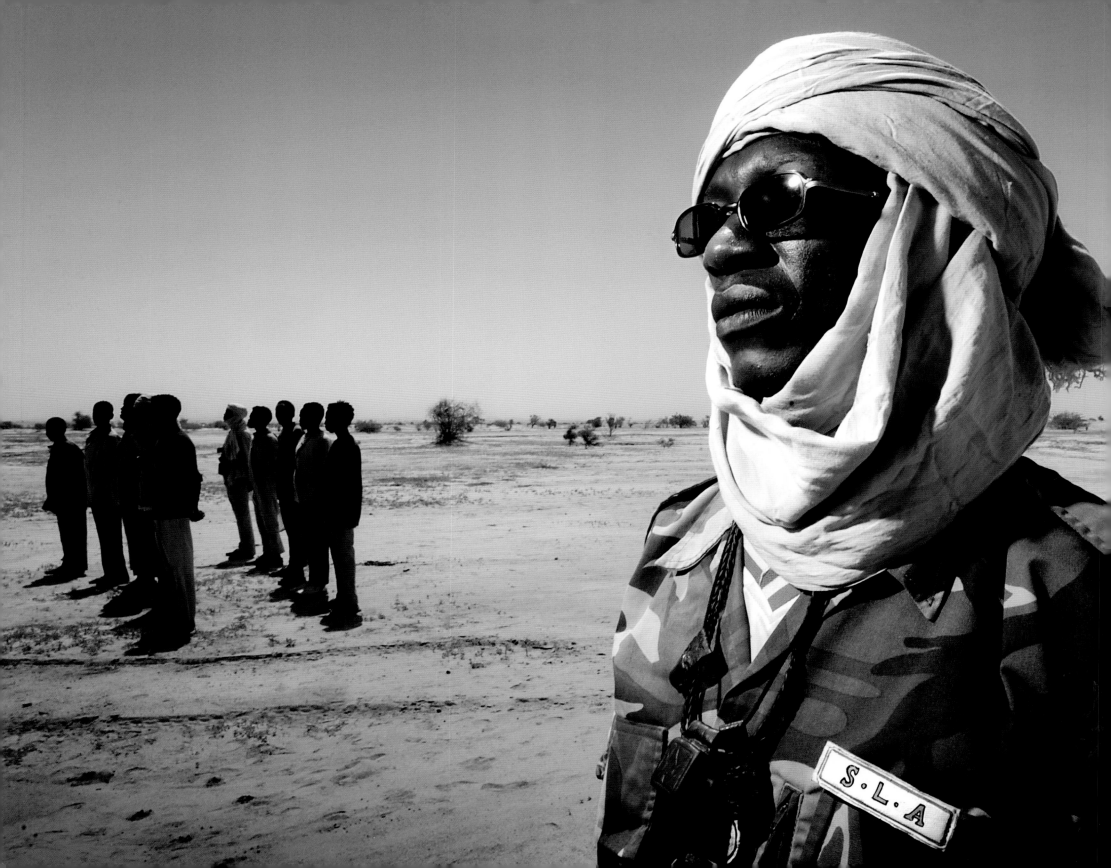

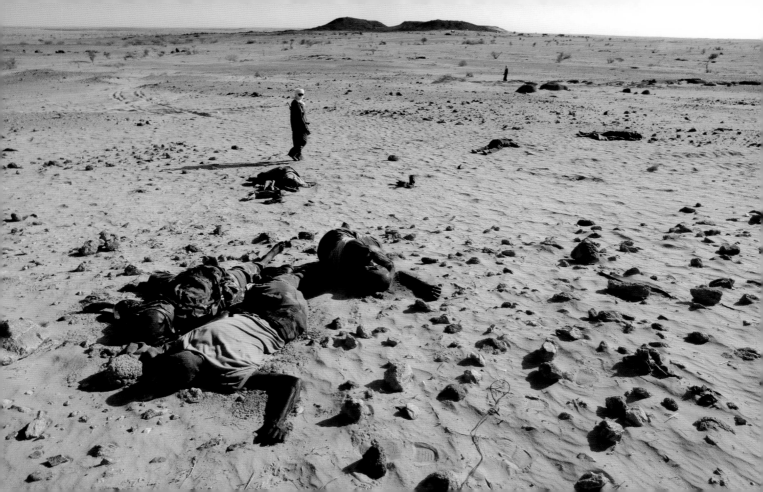

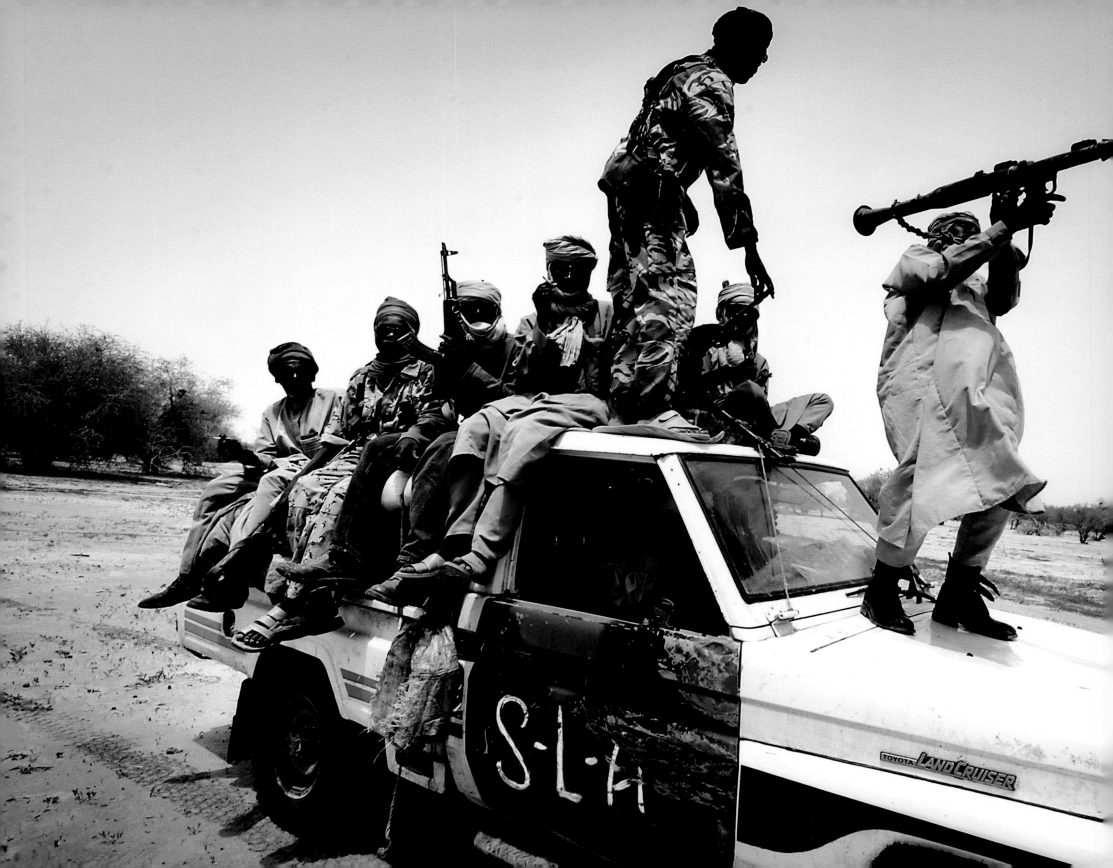

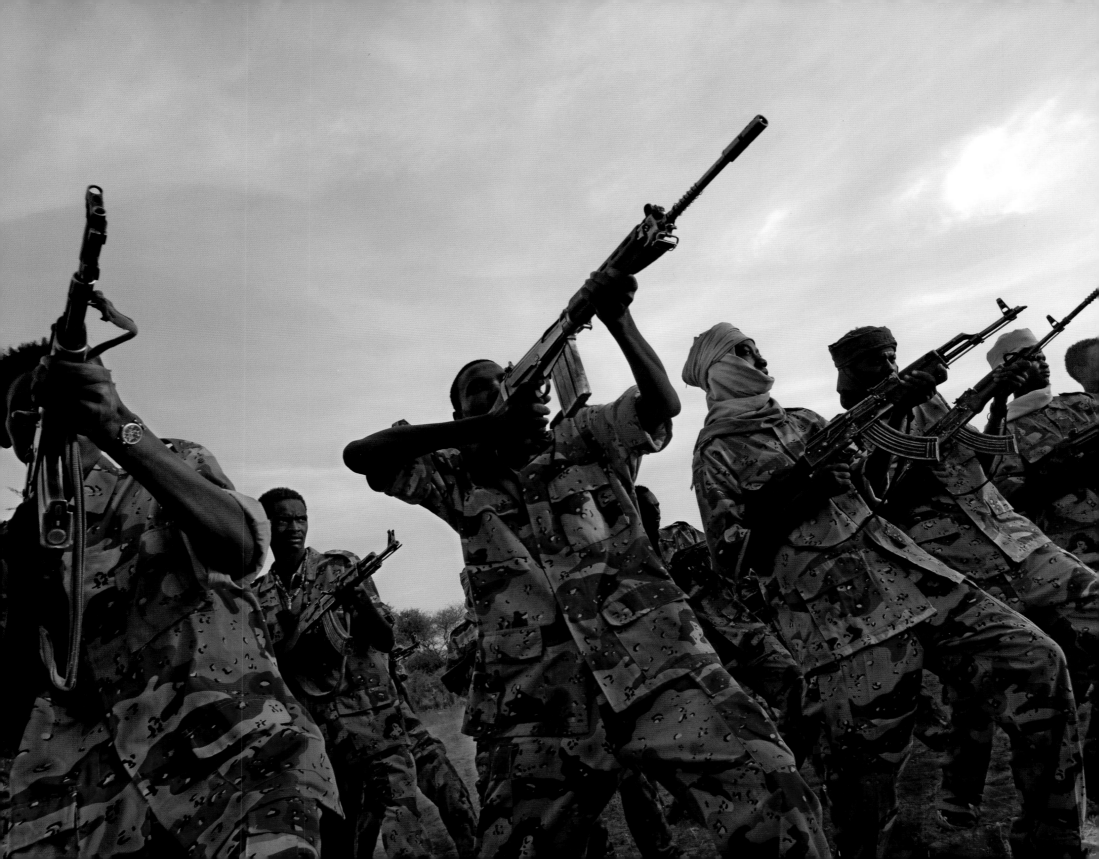

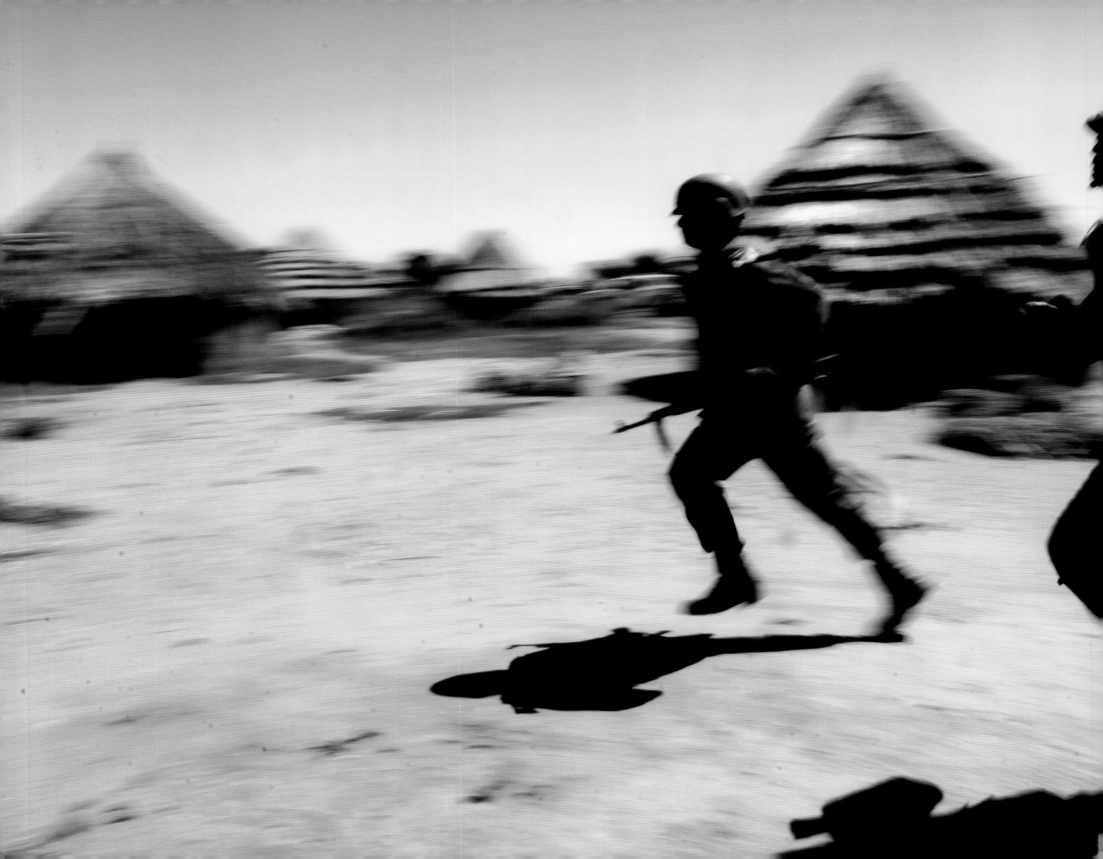

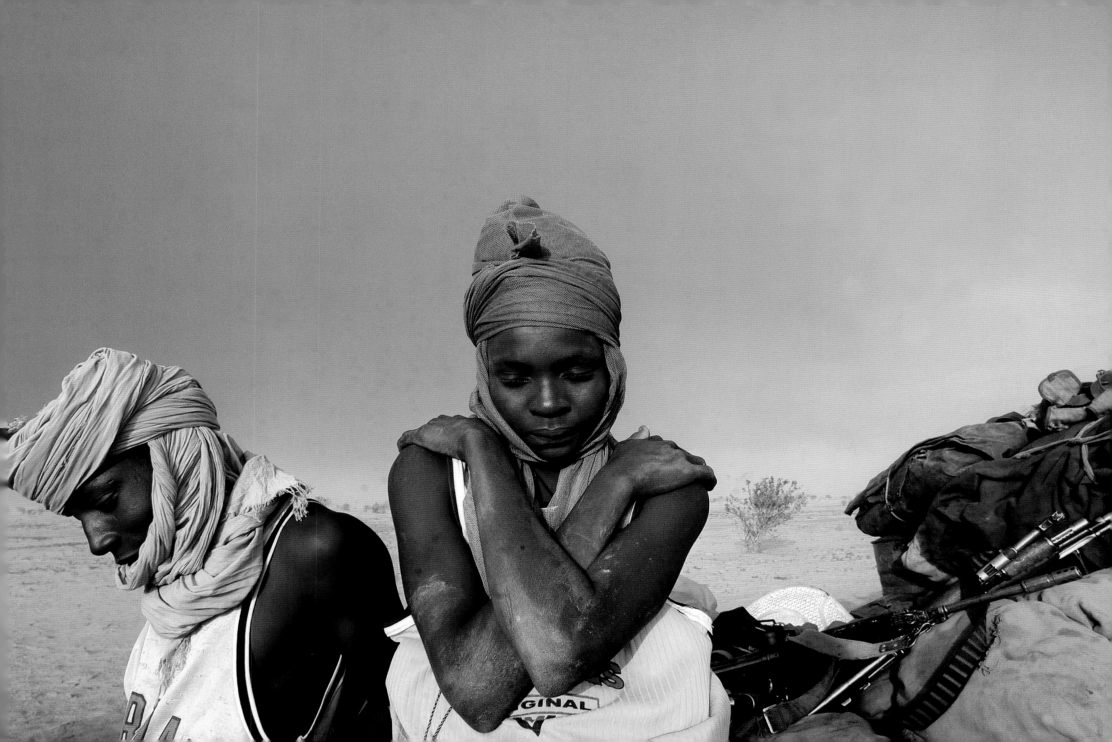

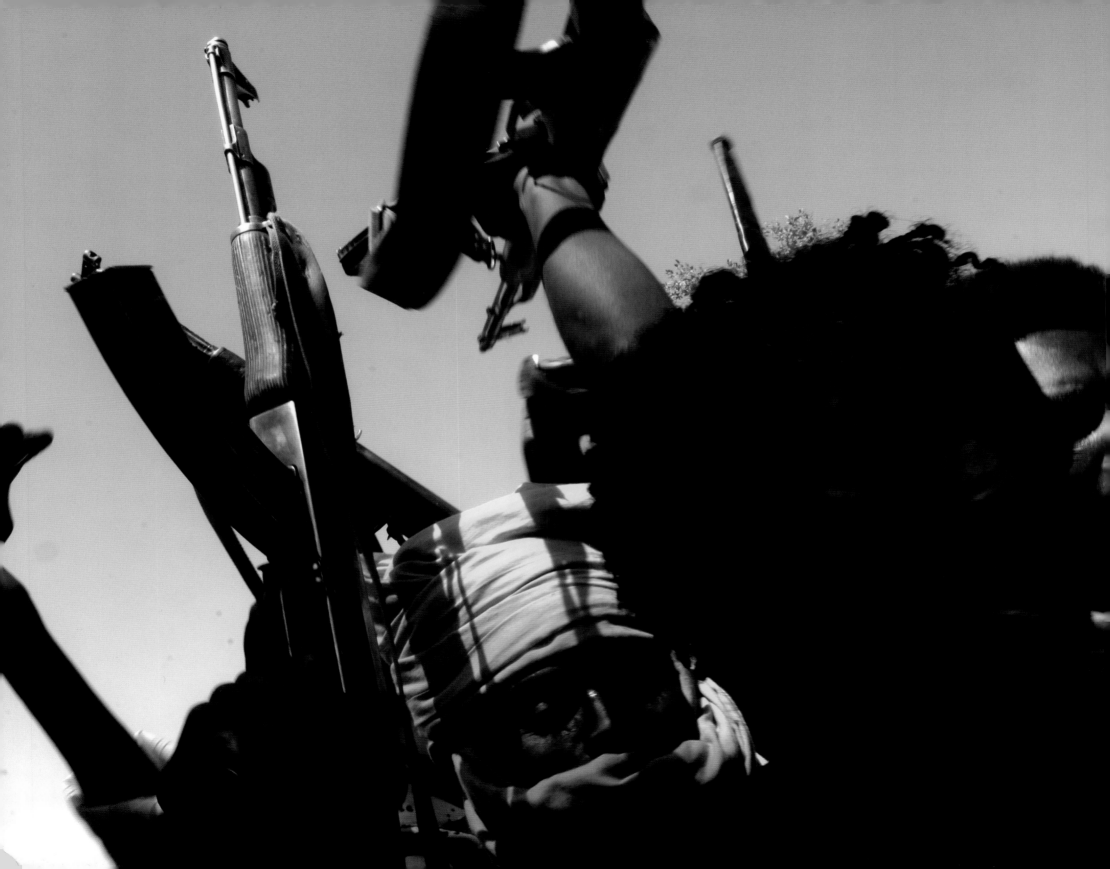

The Little Brothers
John Prendergast

It is moments like this that keep me coming back to Africa's war zones. Here we were, cutting illegally across the border into rebel-held zones of Darfur from the refugee camps in Chad, listening to one harrowing story after another from refugees about displacement, death, destruction, and rape. And then suddenly we come across these two Darfurian boys, brothers, in a little hut in the middle of nowhere.

Two brothers in the middle of rebel-controlled areas of Sudan who wanted to grow up and be journalists. Two brothers who were full of wonder, curiosity, and amazement at their visitors from Mars or Washington or wherever we were from. And two brothers who were at once earnest and playful, wanting to communicate about serious matters but battling over pens, competing to demonstrate whose written Arabic was clearer, and striving to be seen in this vast expanse of the Sahara in which so many have been rendered invisible by the genocide.

I've been volunteering in the Big Brother program back in the U.S. for years, and I also happen to be a big brother to my real-life little brother Luke. I'm a godfather to my nephew Dylan, who looks out for his little brother Michael. And halfway around the world, in a place called Darfur that my real life and program little brothers and nephews back in the

U.S. have only vaguely heard about, two brothers are looking out for each other just like Luke and I did when we were growing up. Just like I look out for my newest Little Brother Jamaar. Just like Dylan looks out for Michael. Except we didn't and don't have to worry about helicopter gunships, militia called janjaweed, being homeless for most of our lives, and losing another brother because he was thrown in a fire.

We had and have it pretty easy.

My dad gave me a little postcard when I was growing up. It had a picture of a bigger boy carrying a smaller boy on his back to give him a chance to rest. The bigger boy says, "He ain't heavy, father, he's my brother." Looking at this picture, remembering these wonderful Darfurian brothers and their infectious smiles, I wish we could help give all the children of Darfur a chance to rest, to learn, to grow, to smile.

John Prendergast is a Senior Adviser at the International Crisis Group. He worked in the White House and the State Department in the Clinton administration from 1996 to 2001.

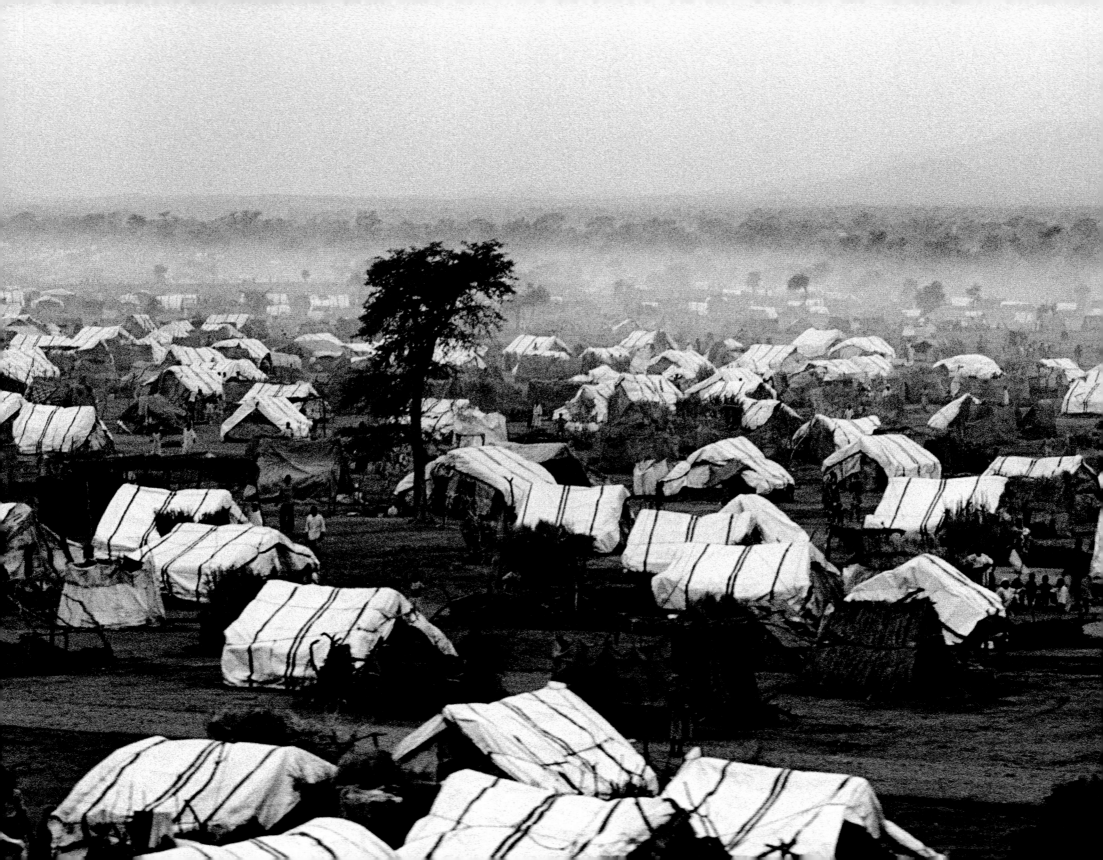

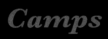

Camps

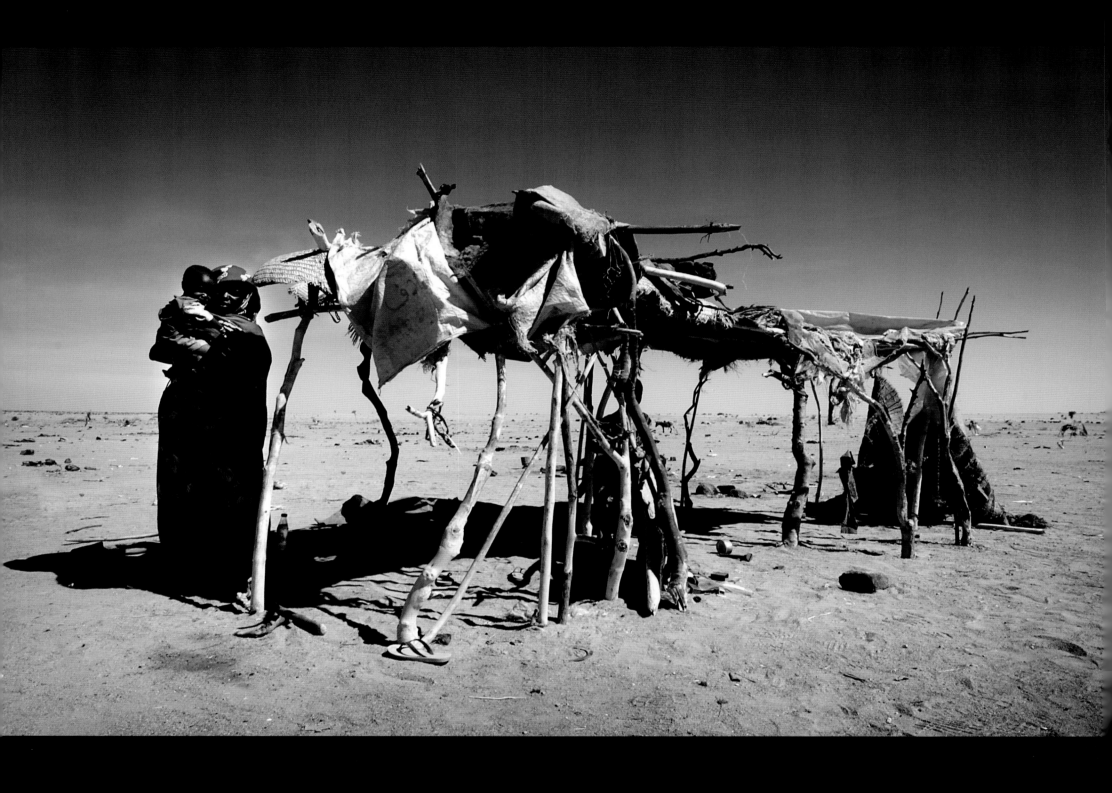

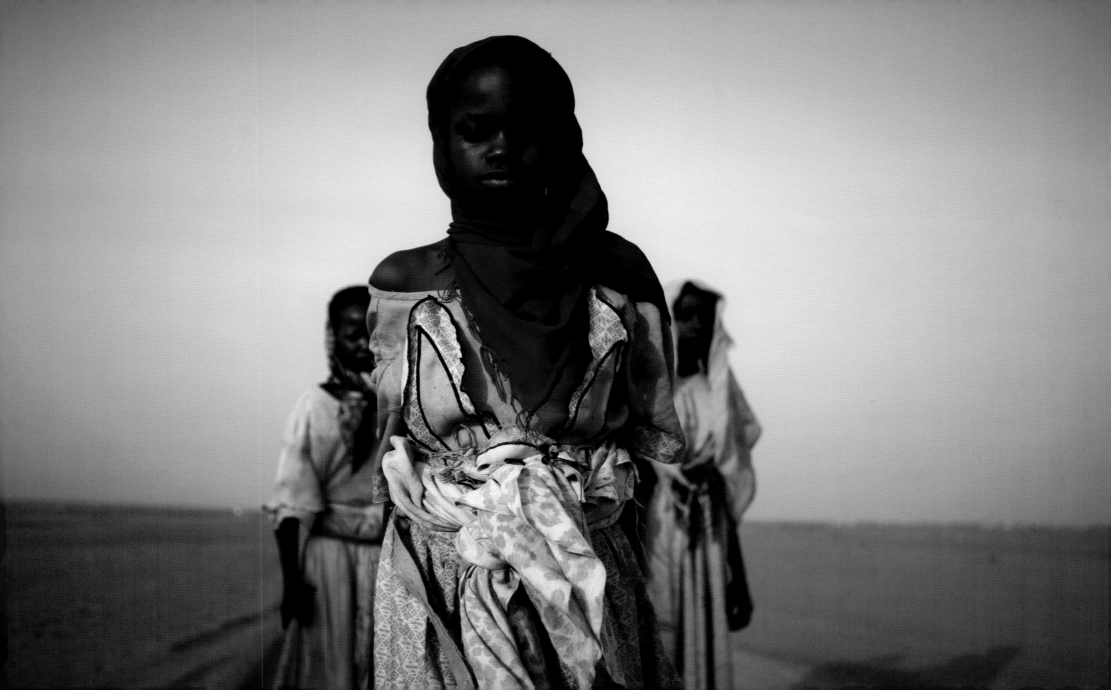

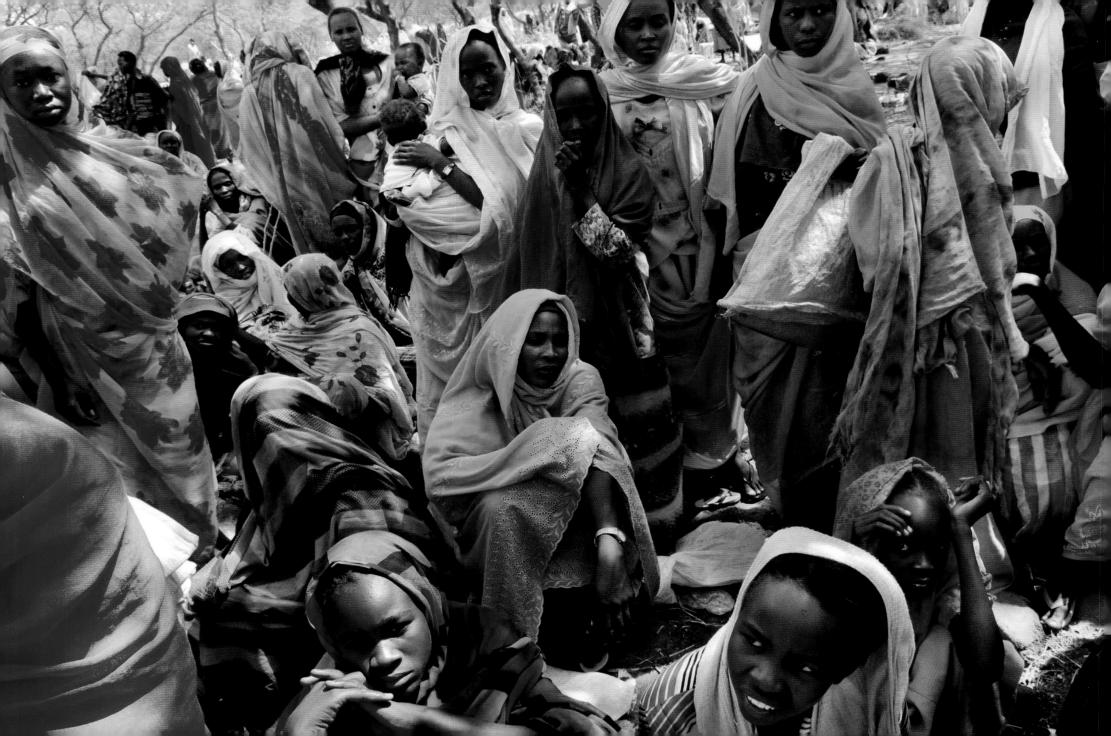

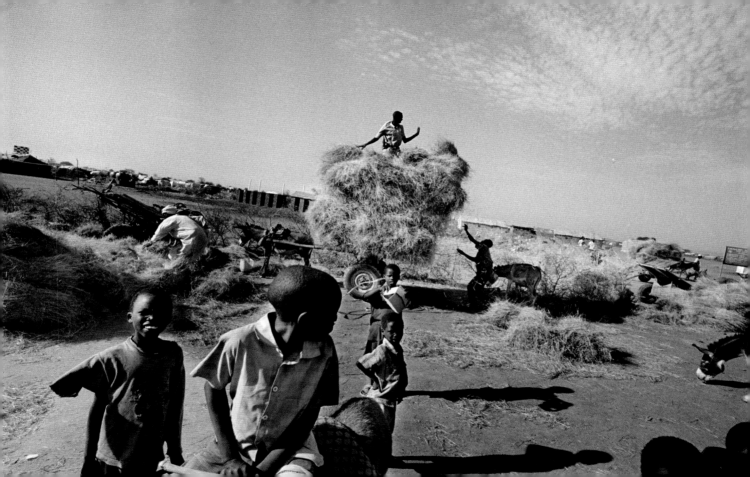

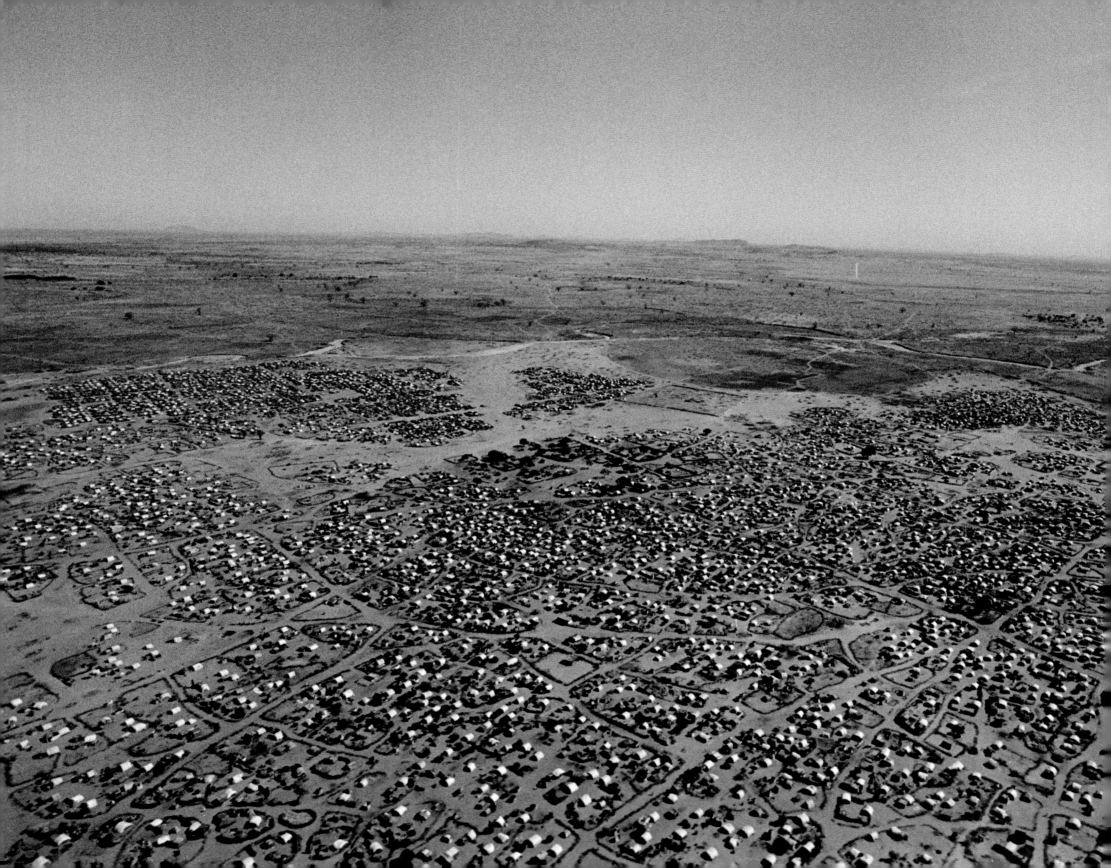

First they took my child off me and threw her on the ground. Then two of the men raped me. Afterwards they left and I picked up my daughter and came back to the camp. I haven't told anyone what happened to me.

Testimony from a woman at an I.D.P. camp near Goz Beida

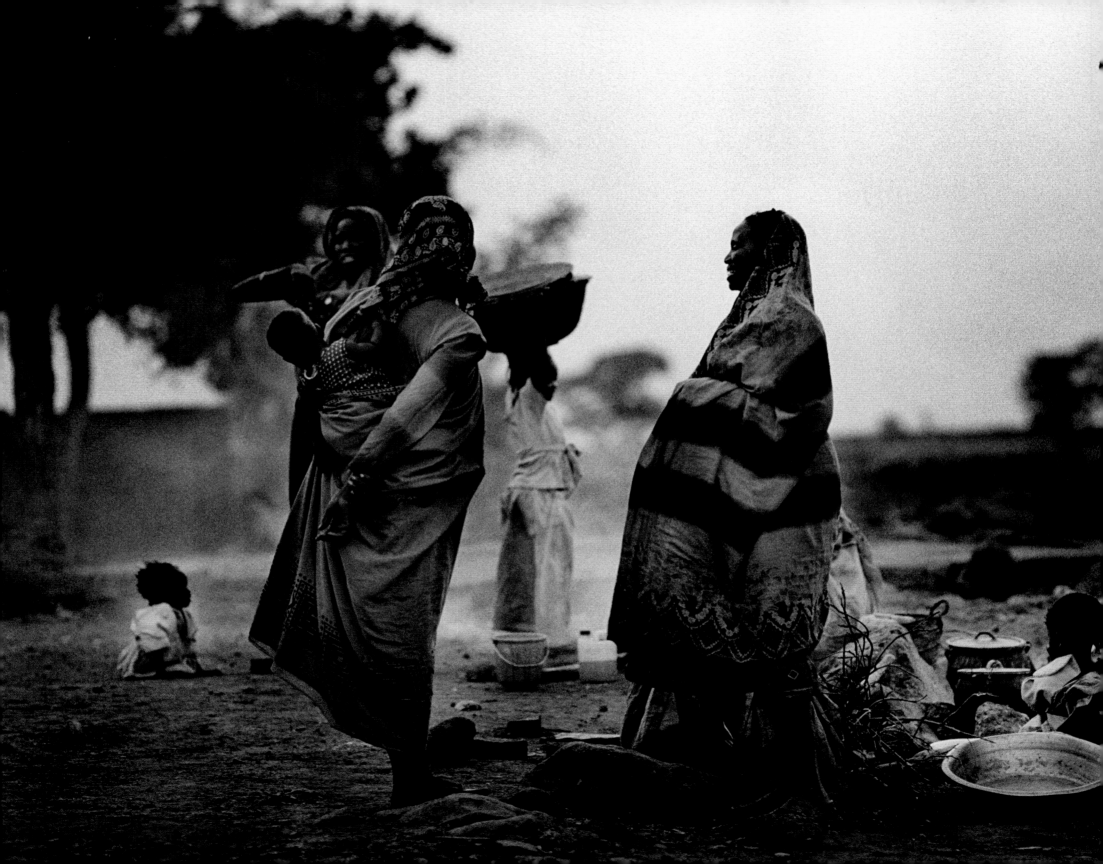

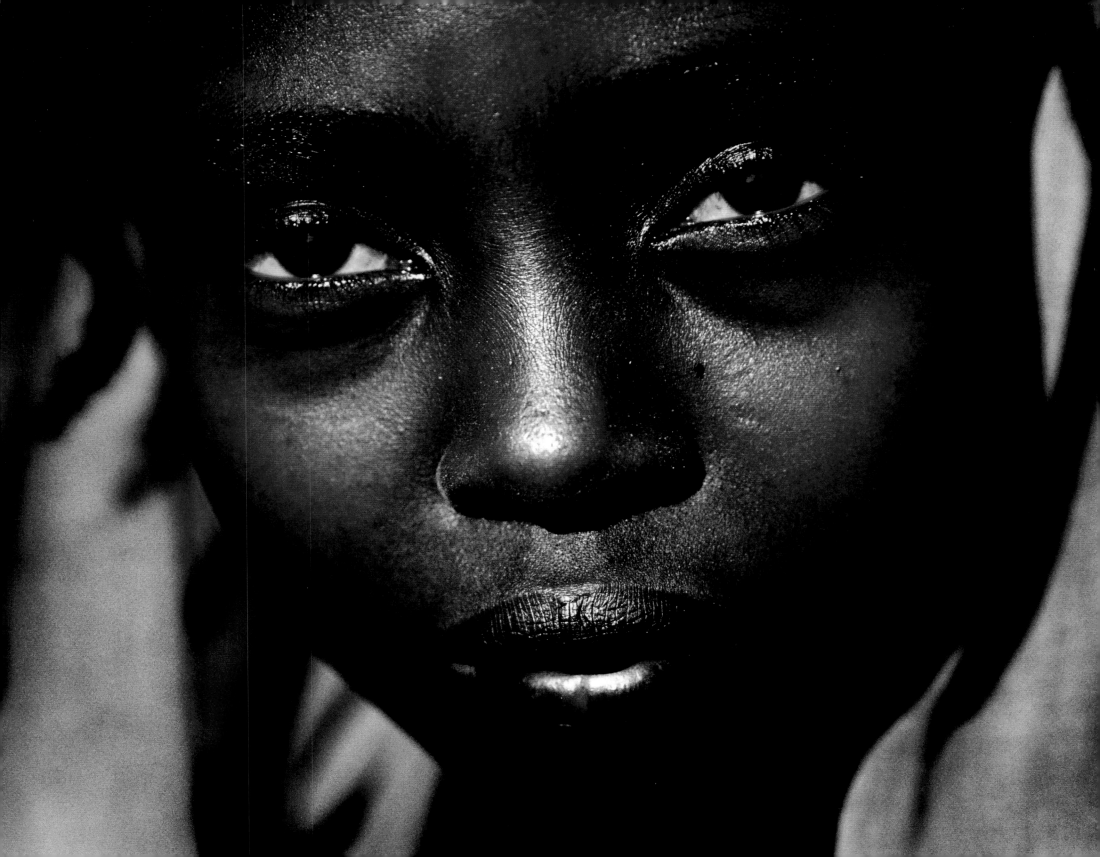

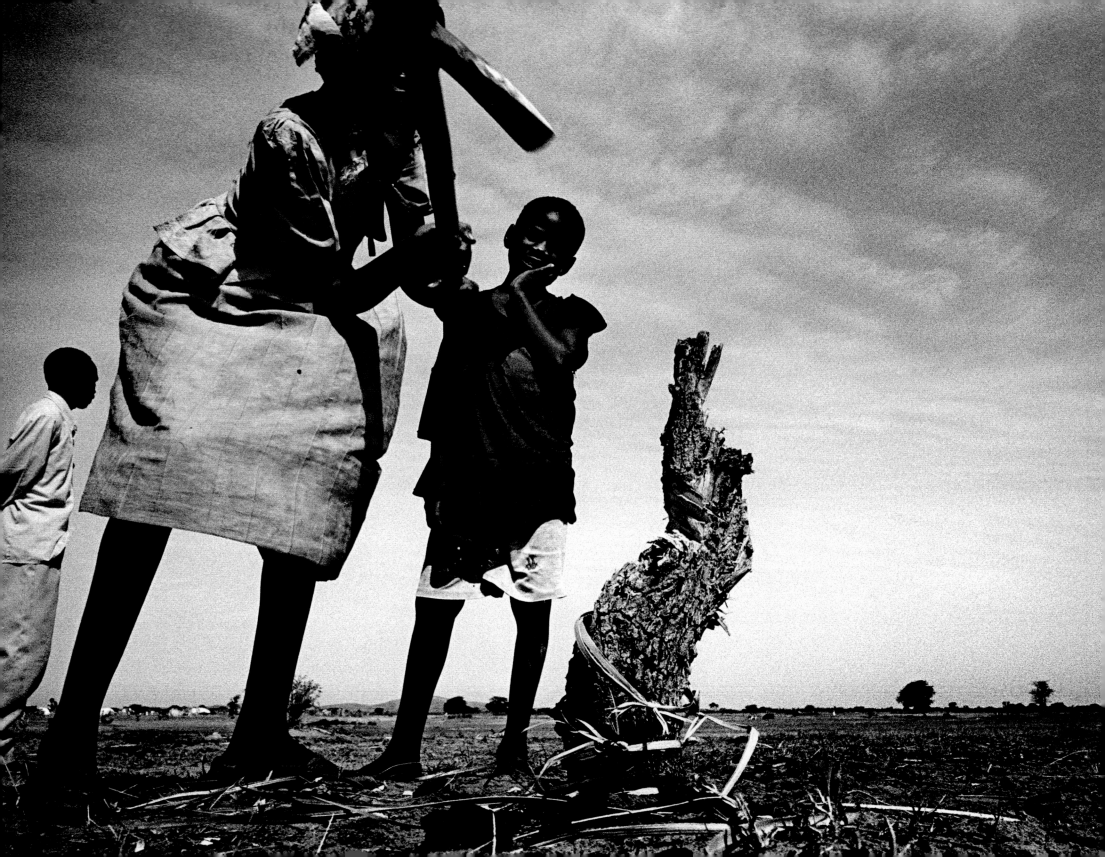

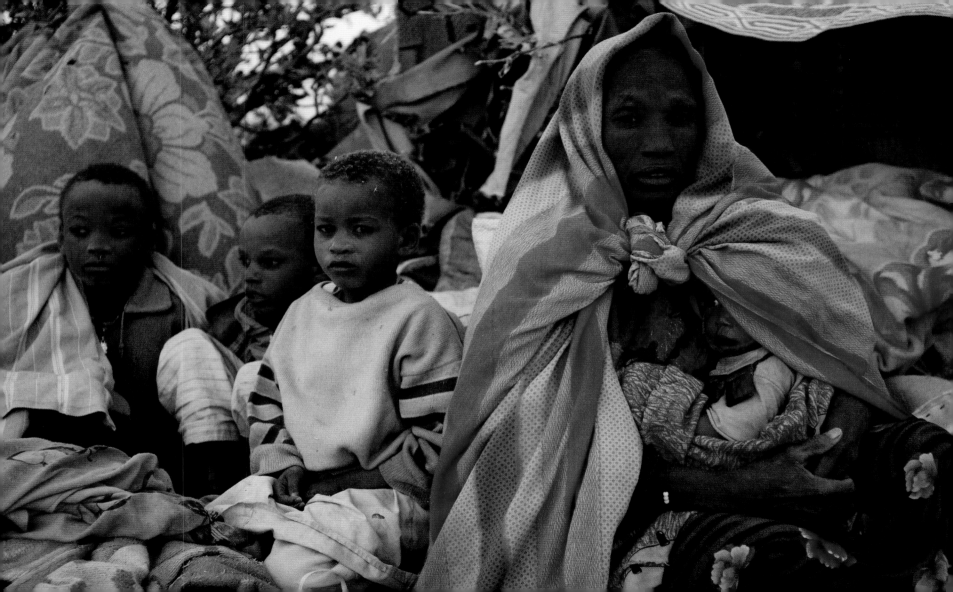

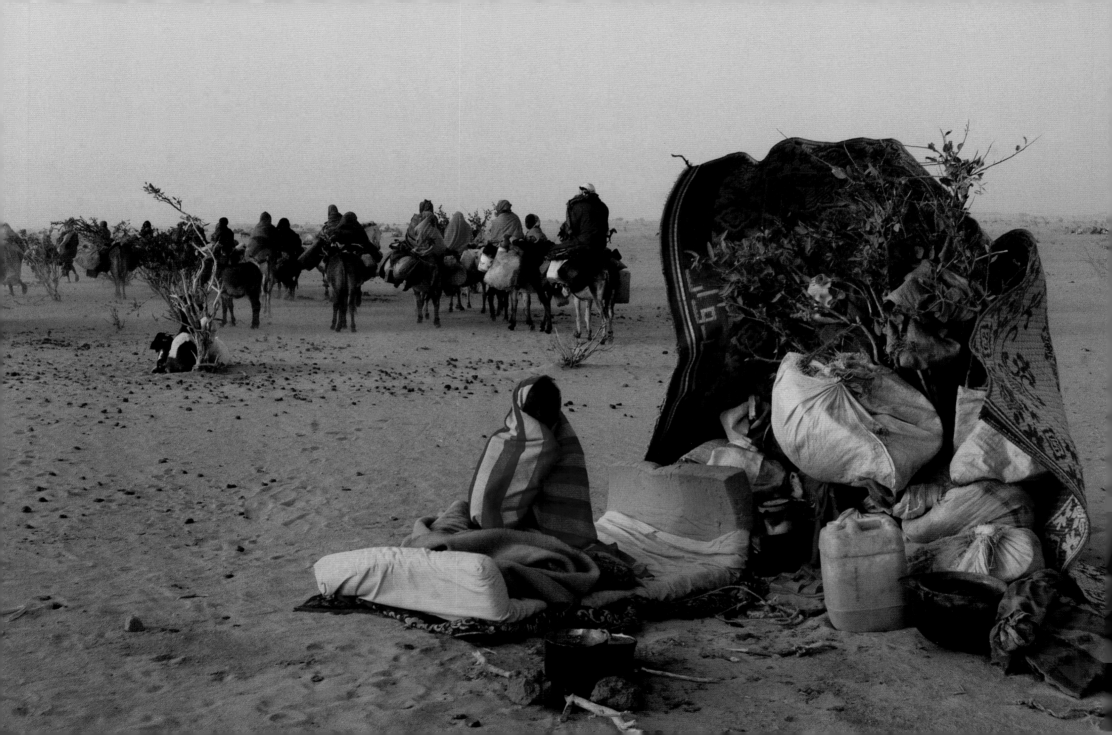

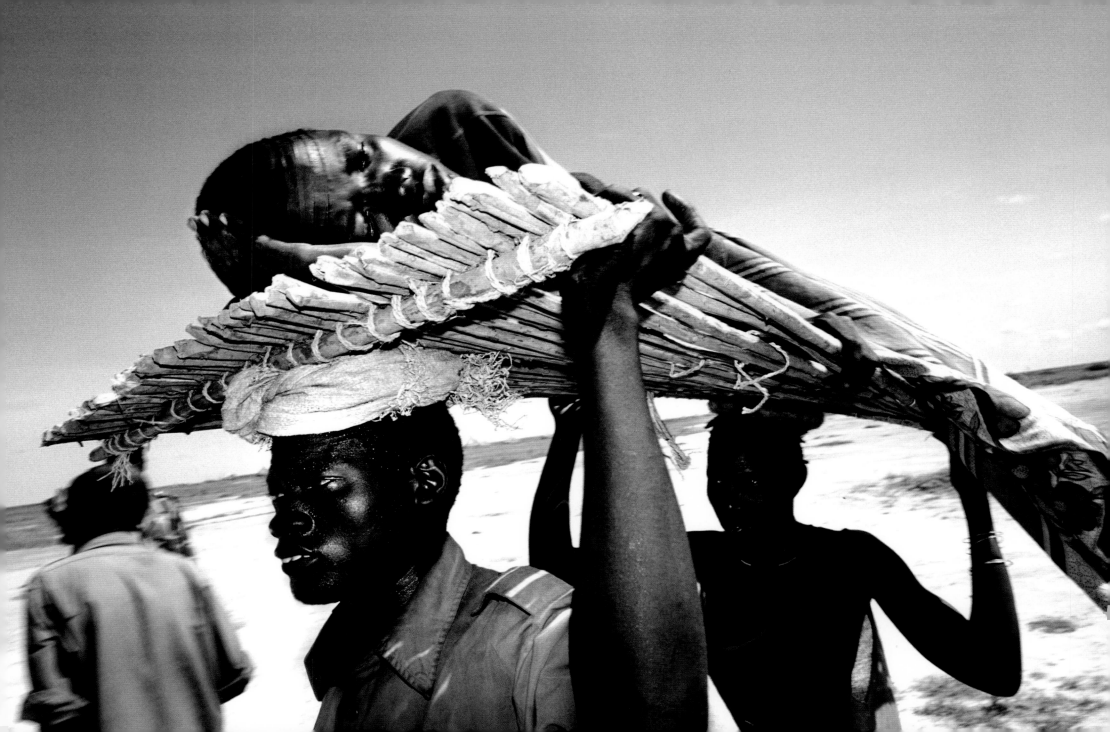

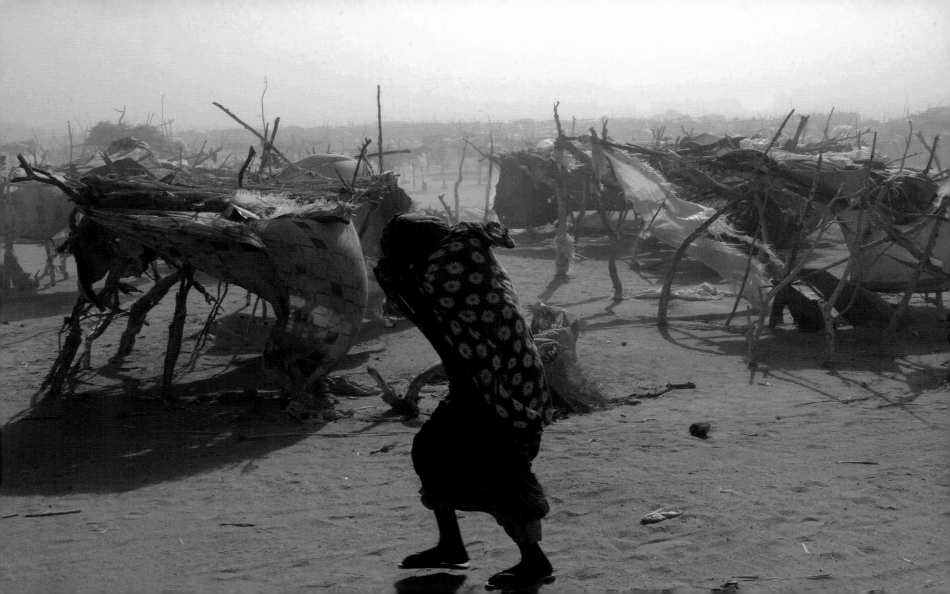

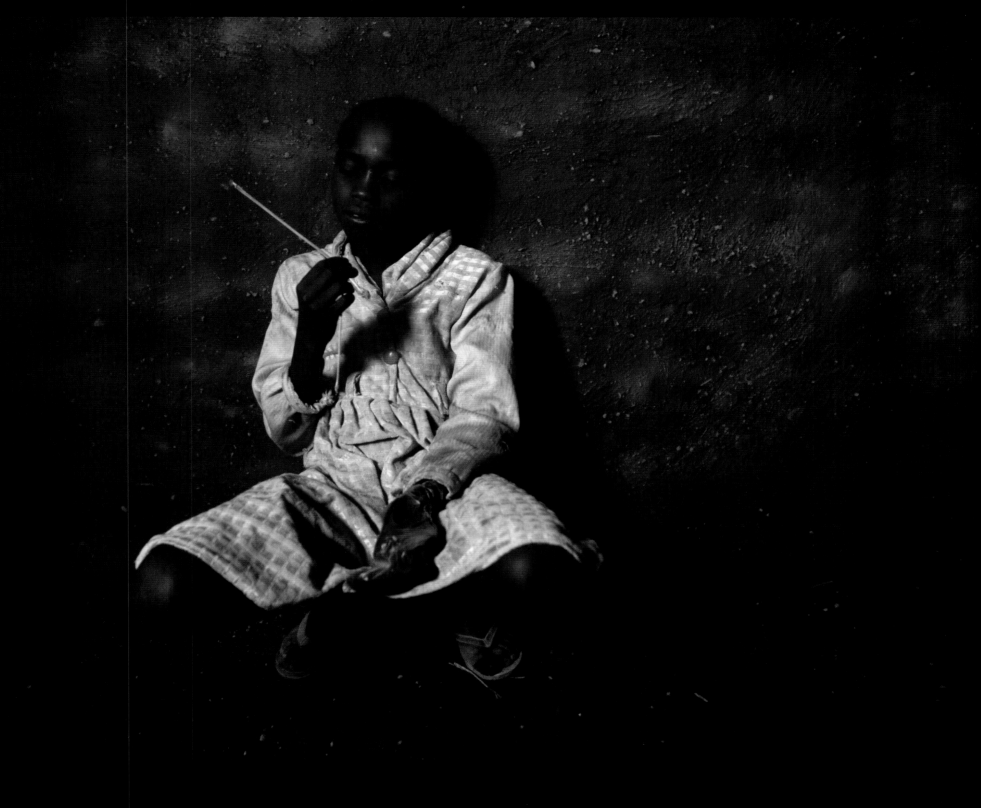

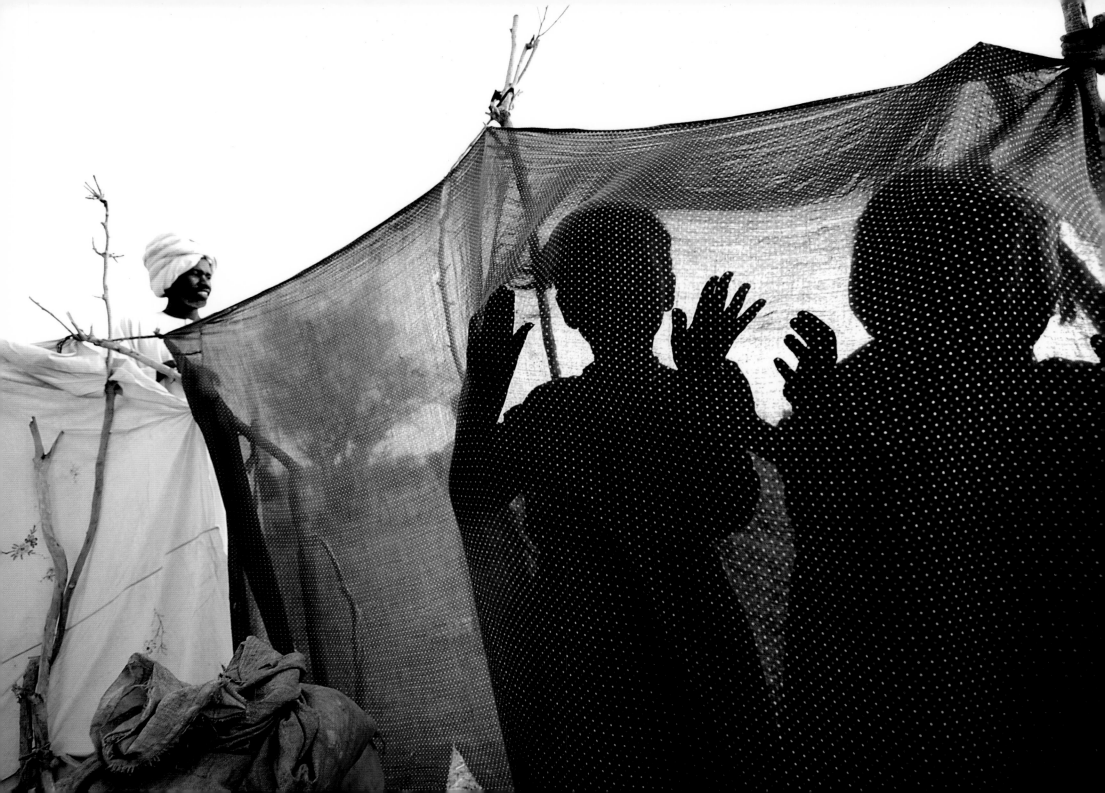

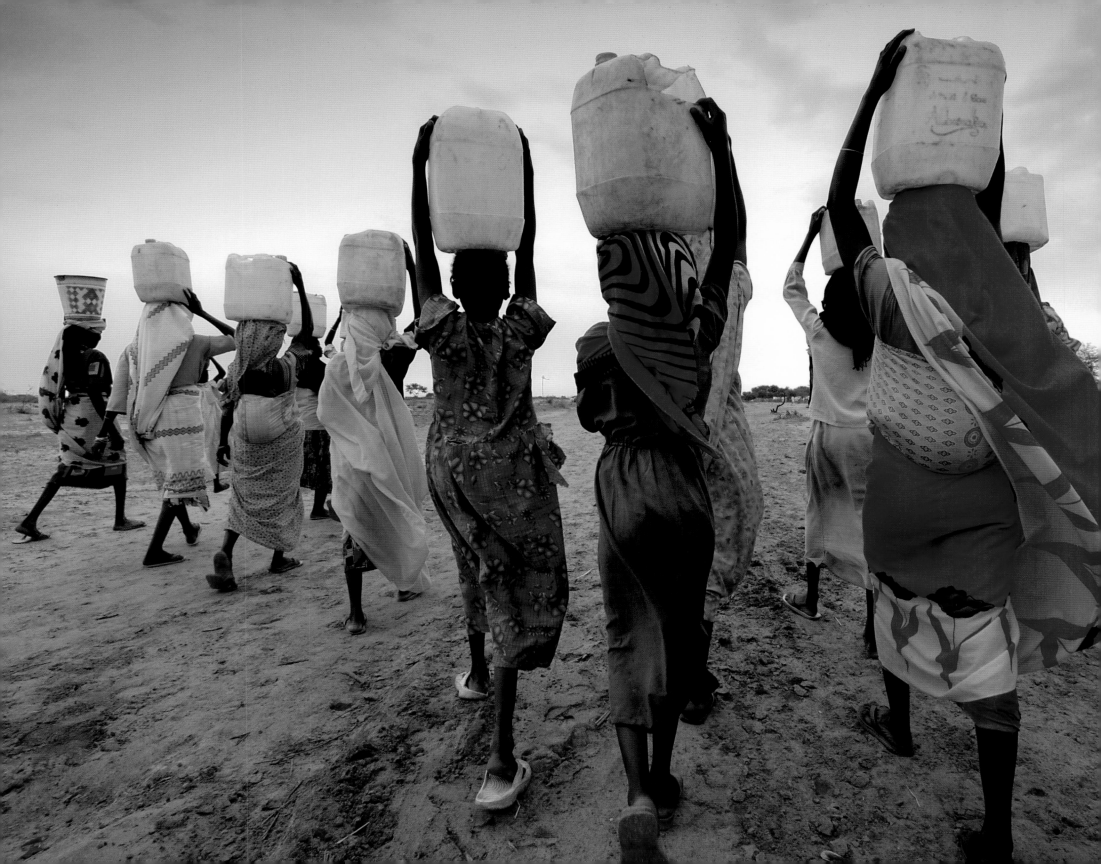

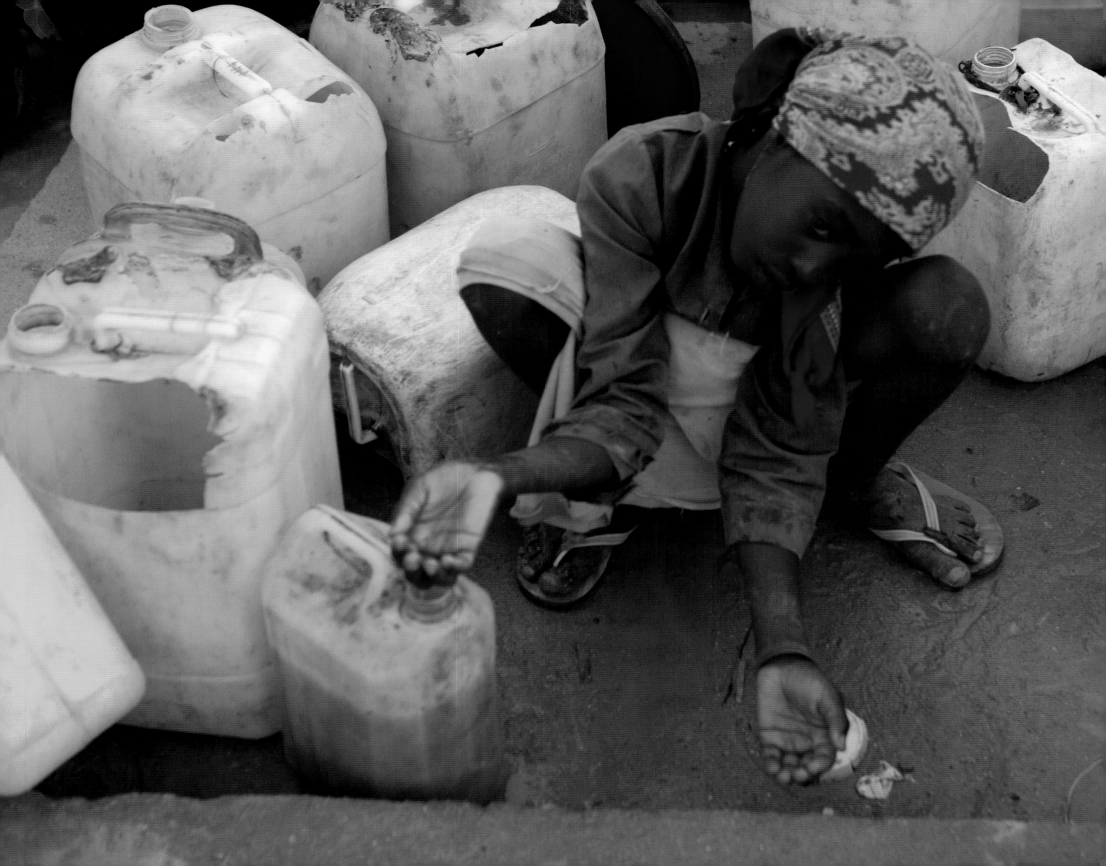

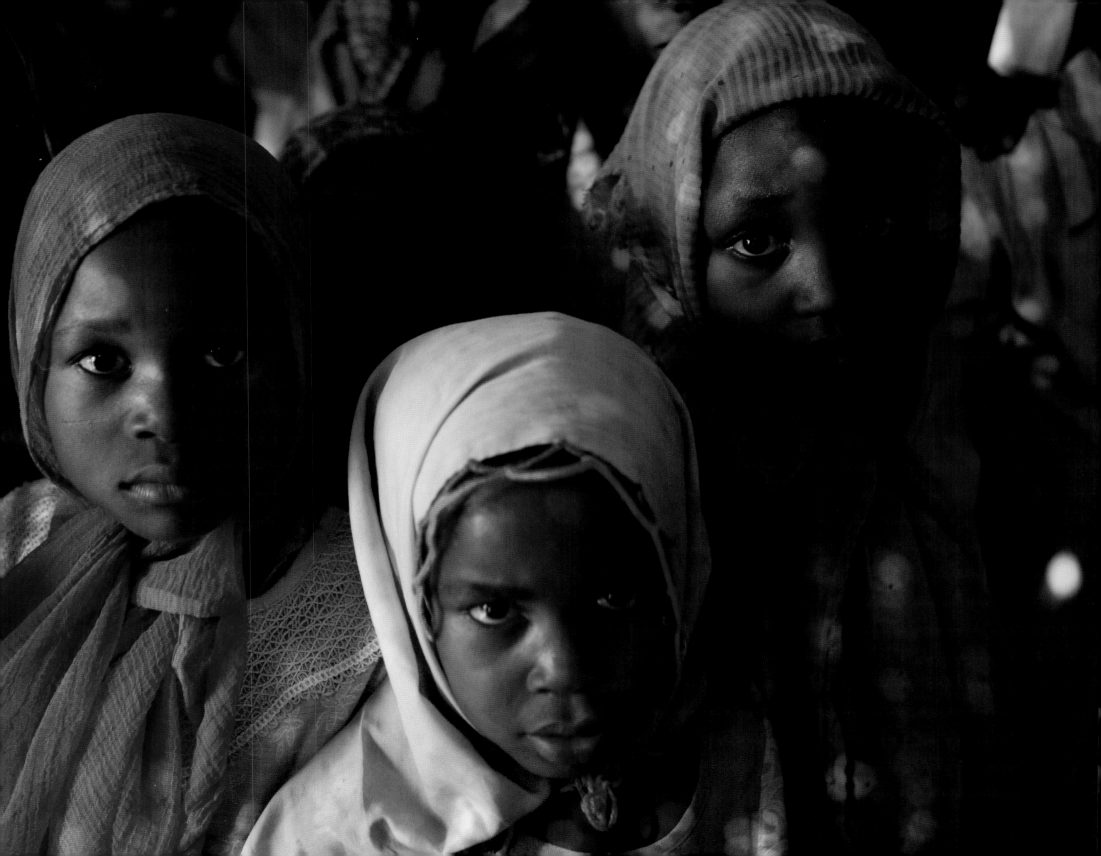

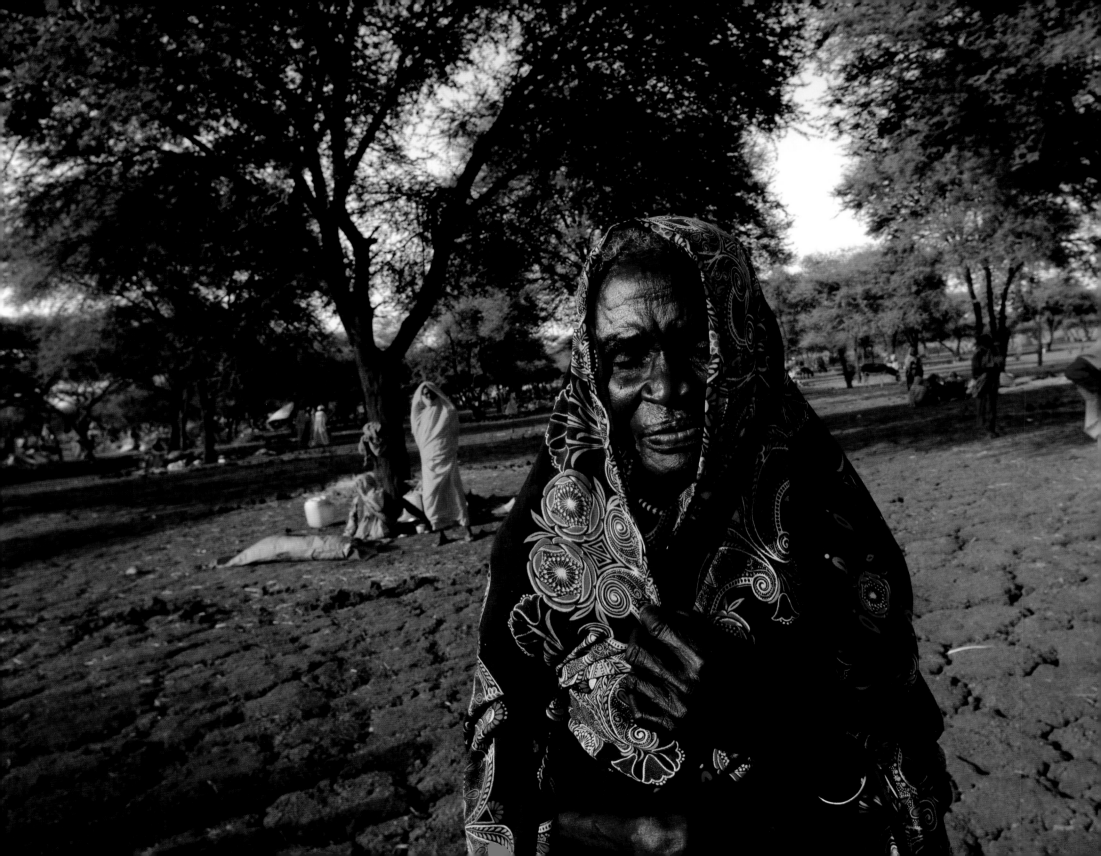

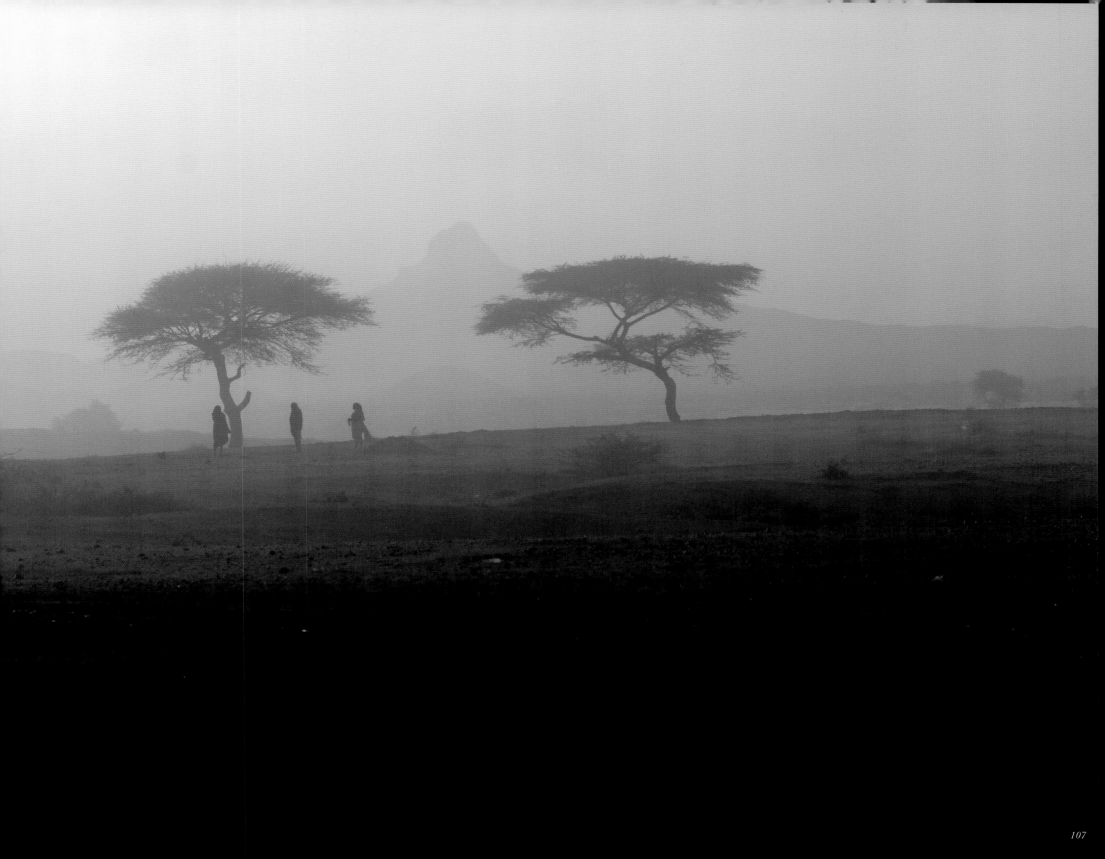

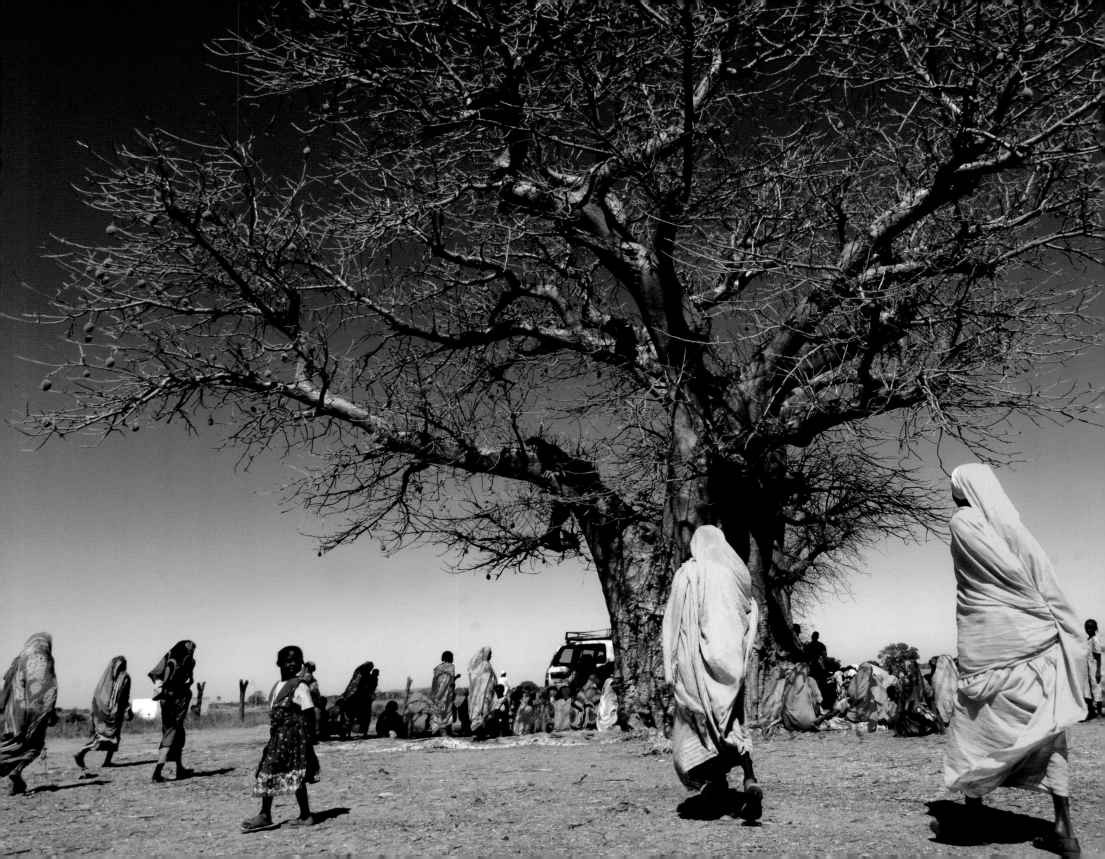

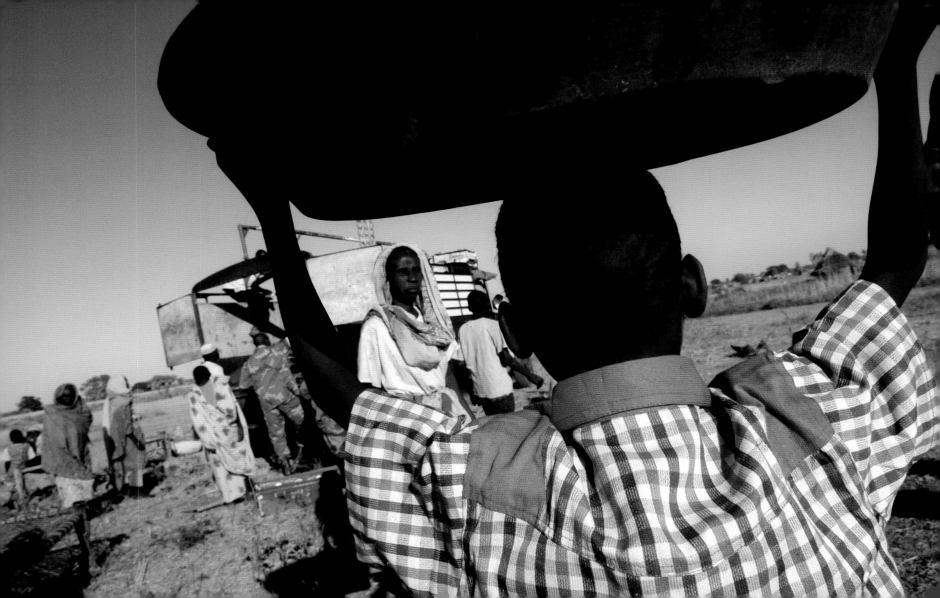

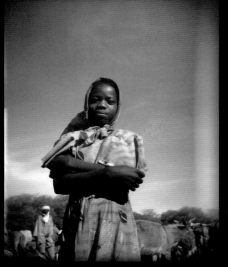

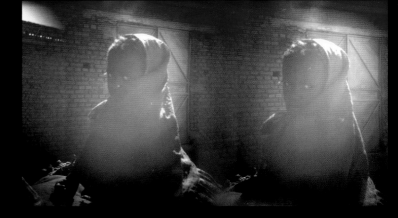

Refugee Camps in Chad
Ryan Gosling

This is a series of photographs that I shot during a visit to several refugee camps in Chad. There I met thousands of children whose lives were, in effect, suspended. They live in limbo in refugee camps, which are just that, a very tenuous refuge from the hostile and dangerous world that surrounds them.

I shot these photographs with a Holga. I took the camera back out so that there would be no frame definition. This created the feeling of both things and experiences blurring into one another, so that the photographs would reflect my experience of the refugee camps.

It is my hope that by looking into these children's faces as I did, others will see how like our own kids they are, and will take up the challenge of seeing that they are not forgotten.

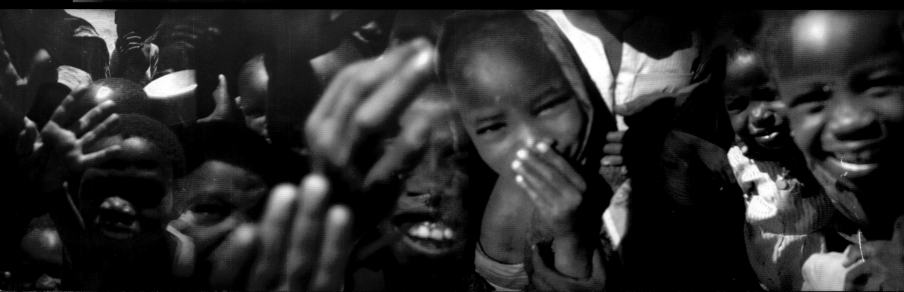

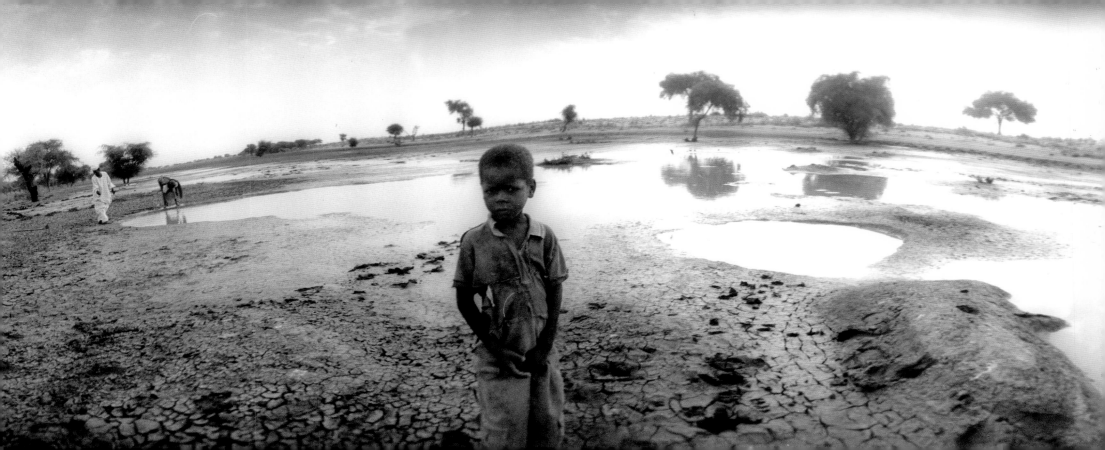

Blood Flows as Red in Chad as in Darfur

Mia Farrow

KOUKOU ANGARANA, Chad—In Goz Beida hospital near the Chad-Sudan border, three men lie side by side, bloodstained gauze covering where their eyes once were. All were attacked by the janjaweed, Arab militia who ride from across the nearby border with the Darfur region of Sudan to brutalize Chadian villages.

Only Abdullah Annour was left with one eye. When the janjaweed attacked him, they noticed his sightless, cataract-whitened left eye.

They cut out his good eye instead.

Mr. Annour is one of the lucky few to have a bed. Most of the wounded at Goz Beida hospital lie on the ground outside, the hospital's six small rooms swollen beyond capacity. I met elderly Djidde Zakaria, lying under a tree nearby. Obviously suffering, her back was wrapped in pus-soaked gauze. "They burned me in my home," Zakaria said.

400,000 people dead, a figure supported by many international aid organizations.

In the last three years more than 200,000 Darfurians have fled here, to Chad. But crossing the border no longer offers any safety.

This year 90,000 Chadians have been forced to flee their homes as Sudanese Arab militia have joined Chadian Arabs in a new frenzy of bloody attacks. Dazed and terrified survivors cluster under trees while aid agencies struggle to respond to the latest rampage of terror. In eastern Chad, 60 villages have been destroyed since November 5, 2006. In one of those villages, Tamadjor, I met Josef Oumar, searching through the ashes of his village. "Janjaweed came from three sides. They were wearing uniforms of the Sudanese army. They attacked us with Kalashnikov rifles. We had only our bows and arrows. Three small children were thrown into flaming huts and burned alive."

The Chadian government is more concerned with protecting itself than its displaced citizens. Chadian President Idriss Deby is in the throes of an insurrection from rebel groups that he believes are supported by Khartoum. The Chadian government declared a state of emergency throughout most of the country on November 13, 2006. The emergency measures provide security for Deby's presidential compound. But the displaced people along Chad's eastern border have been left defenseless in the face of escalating violence between rebel forces and the Chadian army.

Abeche, the largest city in eastern Chad, was recently overrun by rebels. Family members of U.N. staff are being evacuated, and aid workers themselves may follow. This would leave thousands of displaced survivors utterly helpless and without hope.

The displaced people of eastern Chad and the refugees from Darfur urgently need a U.N. presence with a mandate to protect the civilians.

At a meeting about Darfur held in Addis Ababa, Ethiopia in November 2006, France suggested deploying troops along Darfur's long western border to stem the flow of violence into Chad. Sudan promptly rejected the suggestion. However if the deployment takes place within Chad then Sudan's consent is not determinative.

Politically a deployment from within Chad is feasible, both from the perspective of the African Union and the U.N. African Union Chairman Denis Sassou-Nguesso has stated, "We agree with the idea of sending U.N. troops to ensure security on the borders of Chad." The U.N. Security Council resolution that authorized a U.N. force to protect Darfurians also decided that the mandate of the U.N. mission in Sudan shall include "the establishment of a multidimensional presence consisting of political, humanitarian, military, and civilian police liaison officers in key locations in Chad, including in internally displaced persons and refugee camps."

That may be the only remaining hope for the anguished people of eastern Chad. For three years we have watched and done little as Darfur burned. We cannot continue to stand by as the same fate befalls eastern Chad. A robust U.N.-backed force must be deployed to halt these atrocities.

Mia Farrow is a award-winning actress who has been a UNICEF Good Will Ambassador since 2001.

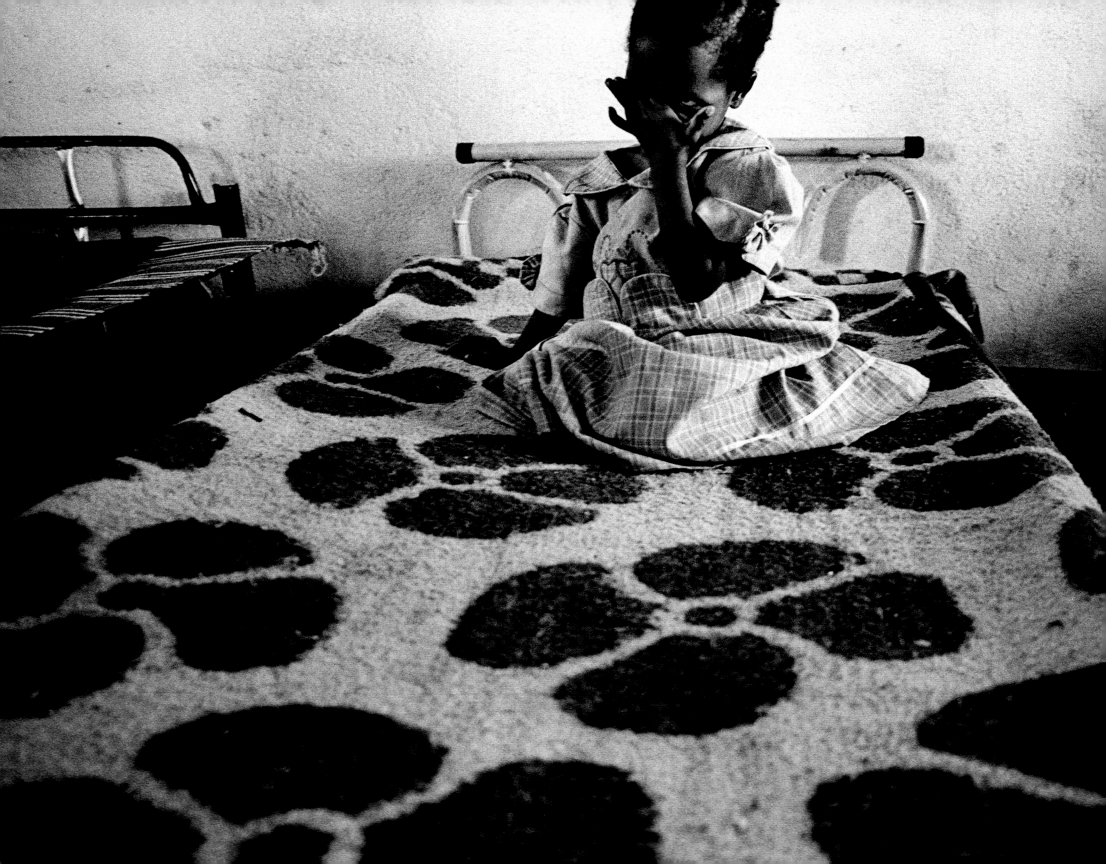

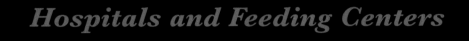

Hospitals and Feeding Centers

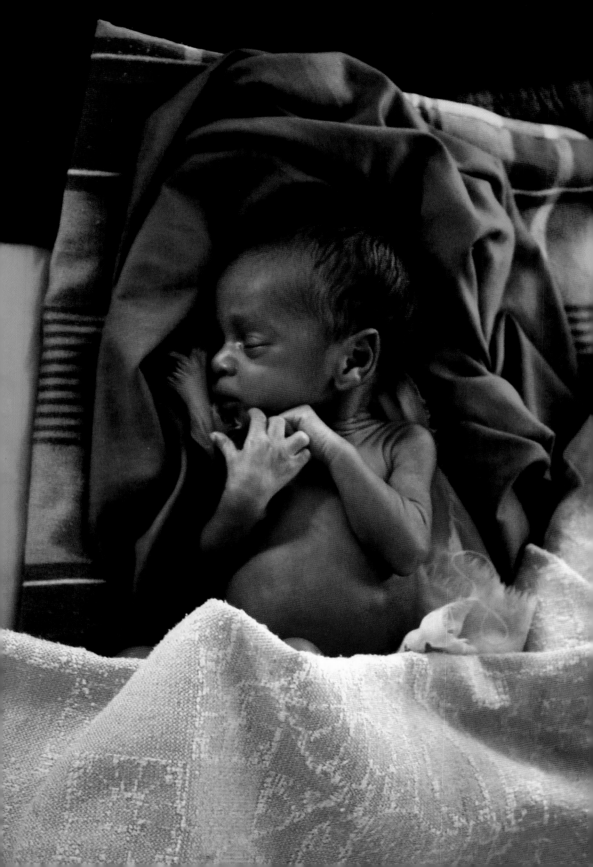

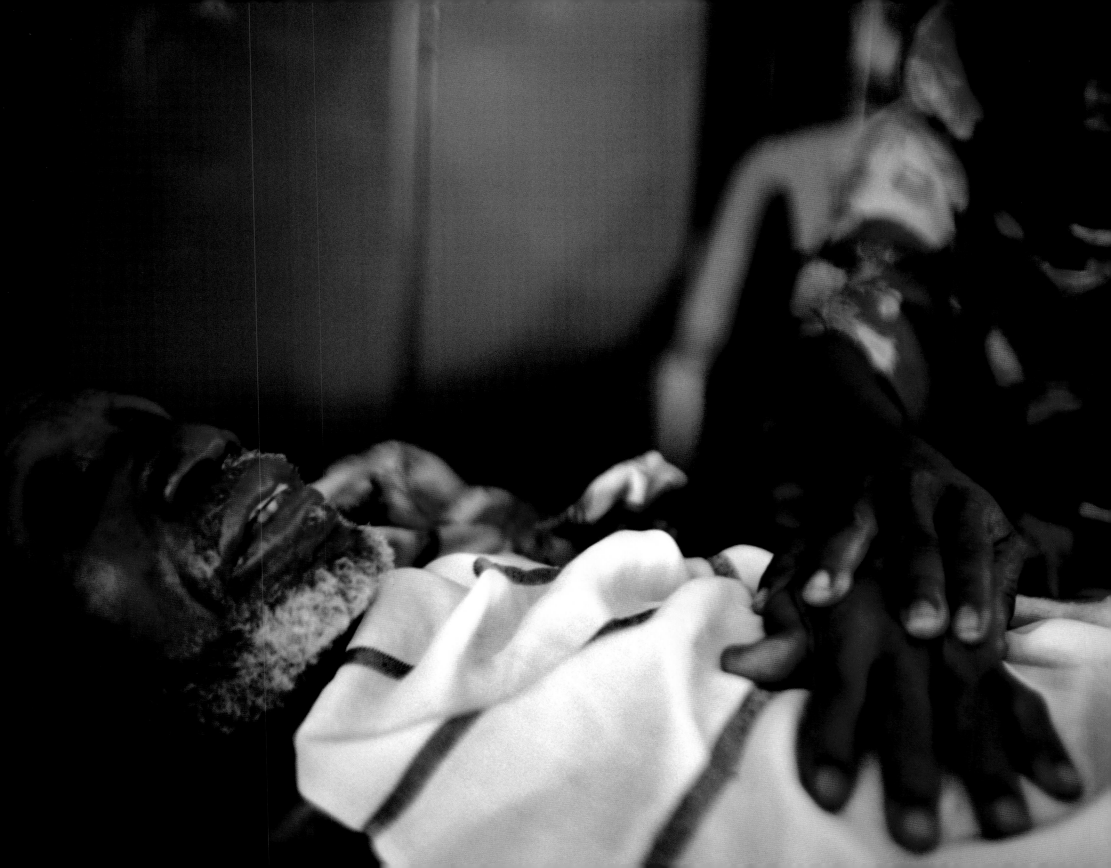

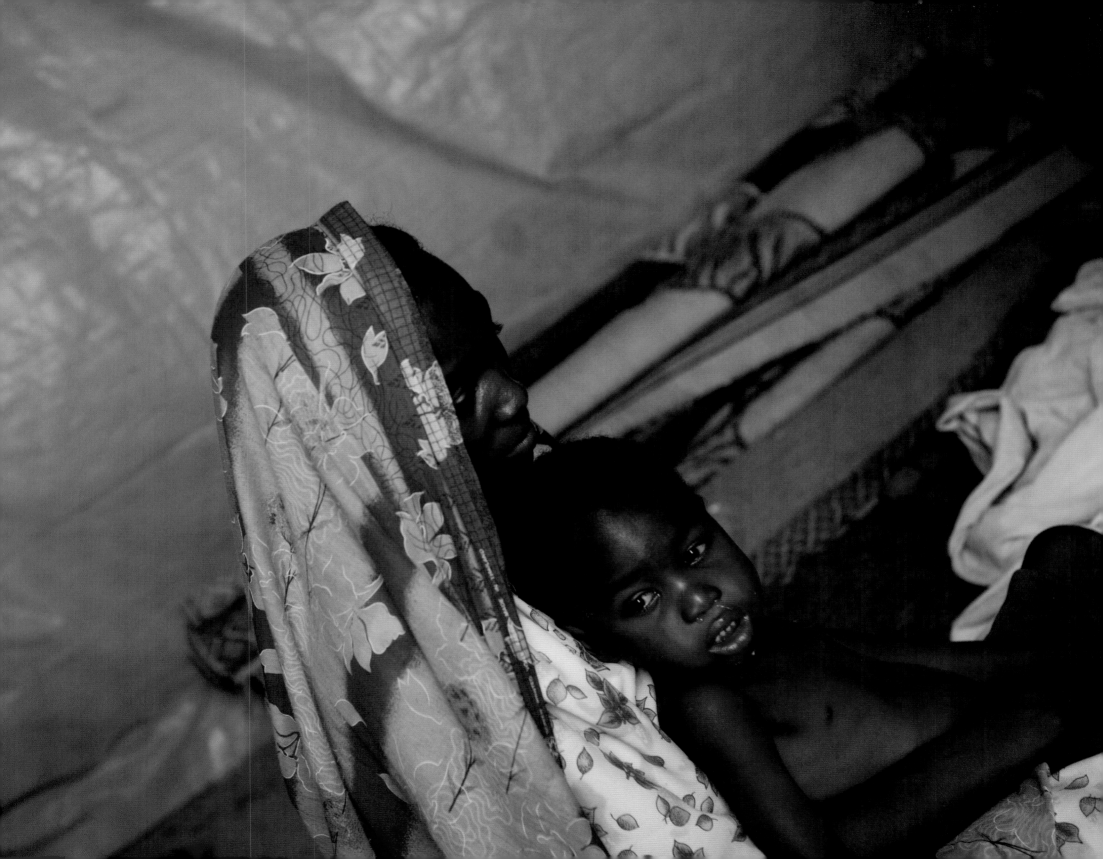

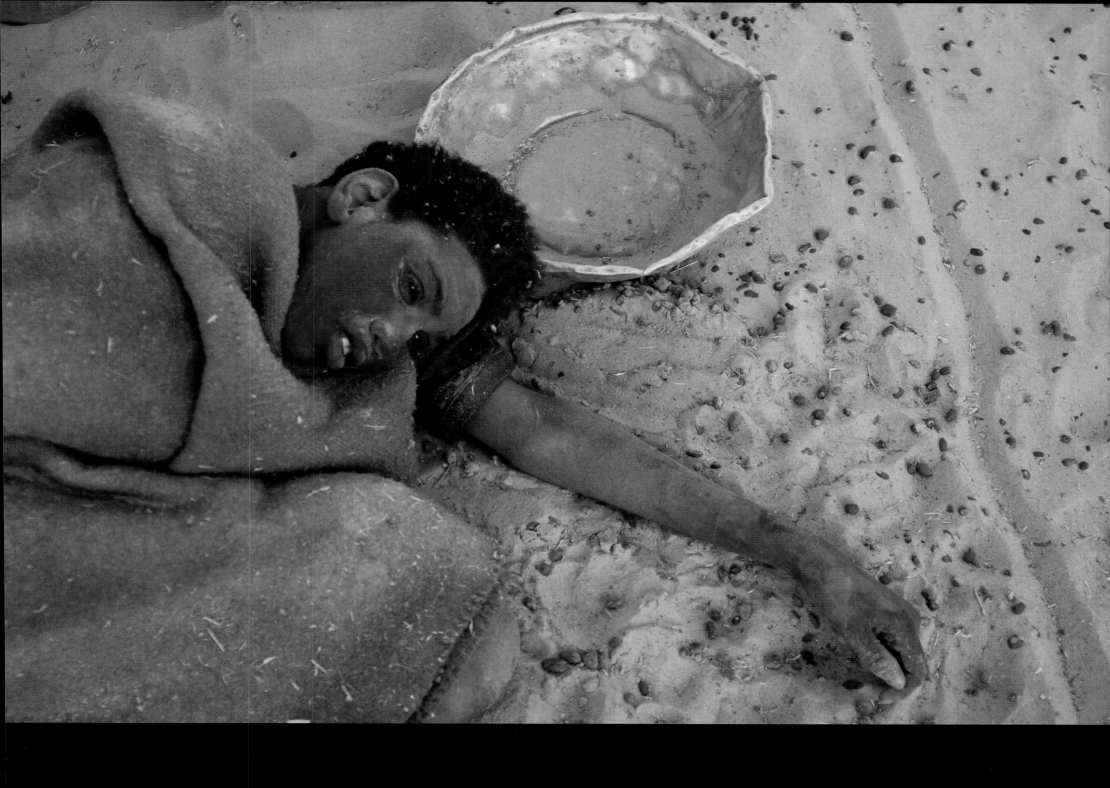

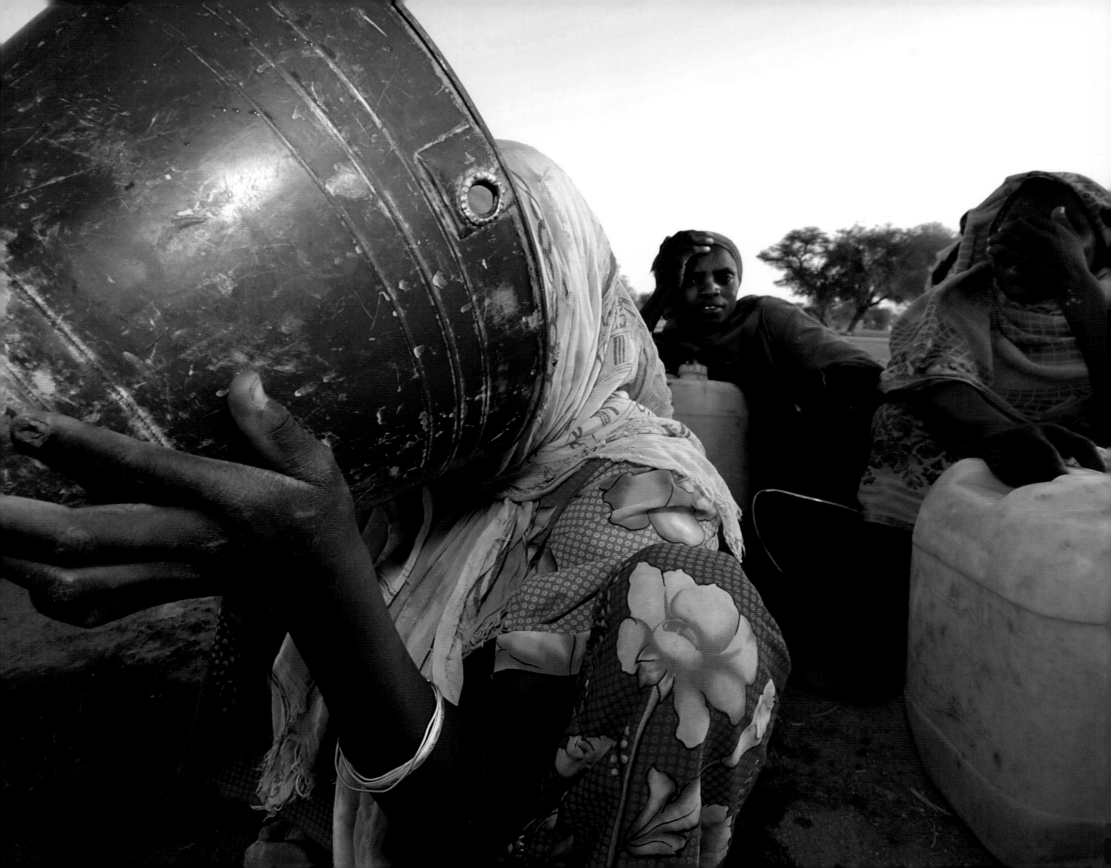

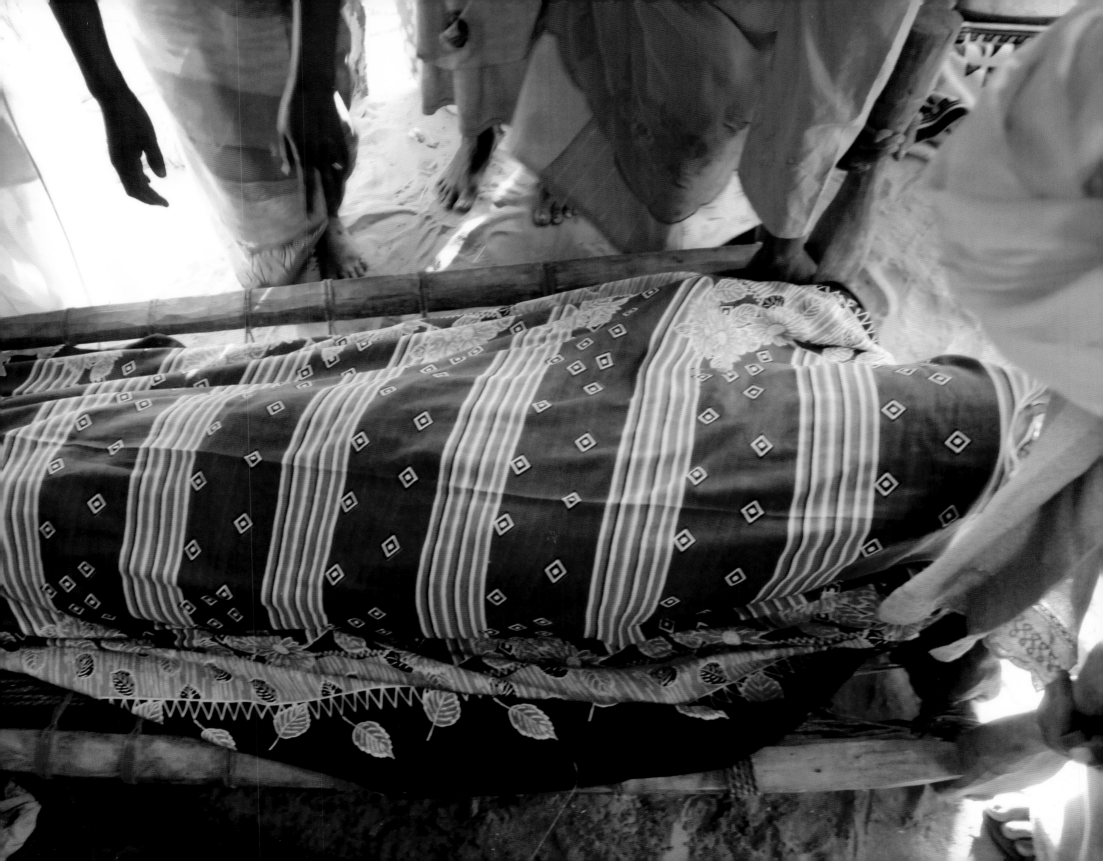

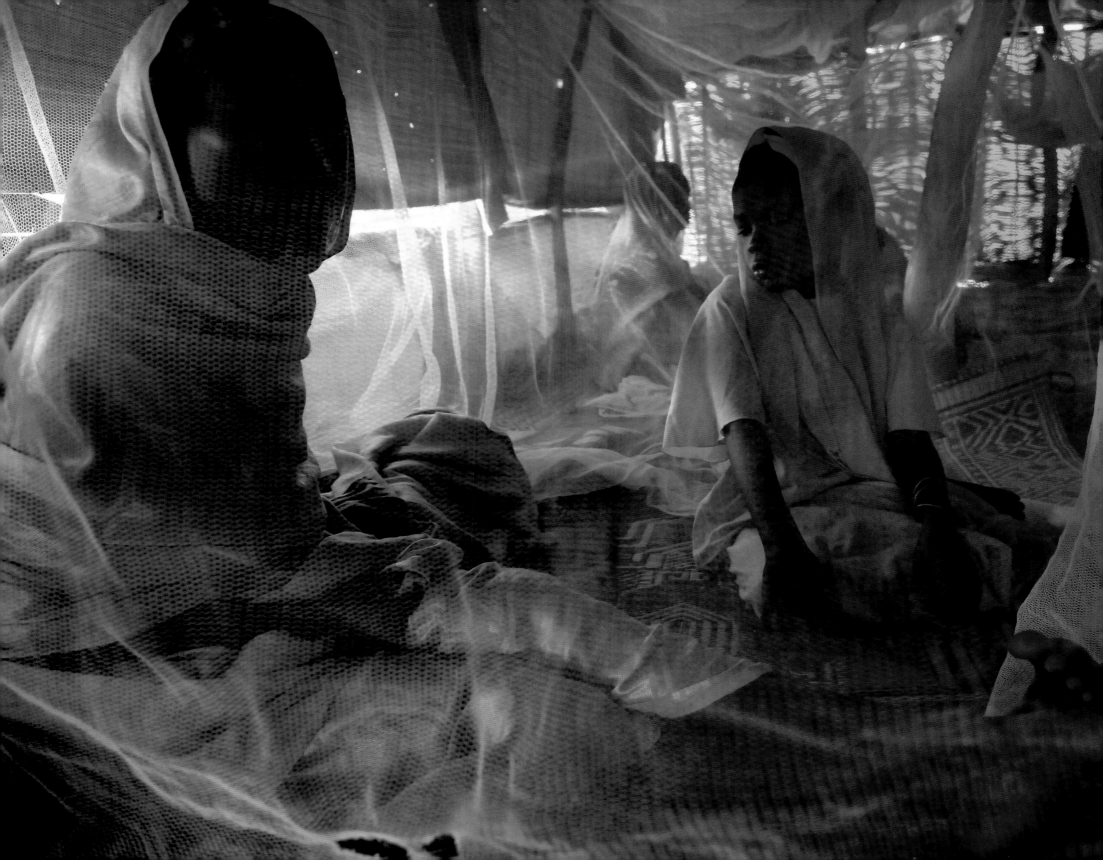

I was taken in a room with ten men; they took my *tobe* [women's clothing] and put a cloth on my eyes. They lifted my clothes and began to punish me with a belt until the evening. They pulled my nails with a cutter until I bled, they pricked me with a pen and said: "you will confess to this story." They also made me spend a day under the sun. I was then transferred to another room and they kicked me with their shoes and punched me. I am still suffering on my left and right side.... After this torture I was forced to confess to this story. I didn't sign anything but they wrote a document.

Mariam Mohamed Dinar, one of twelve persons arrested by the "positive" security in August 2004

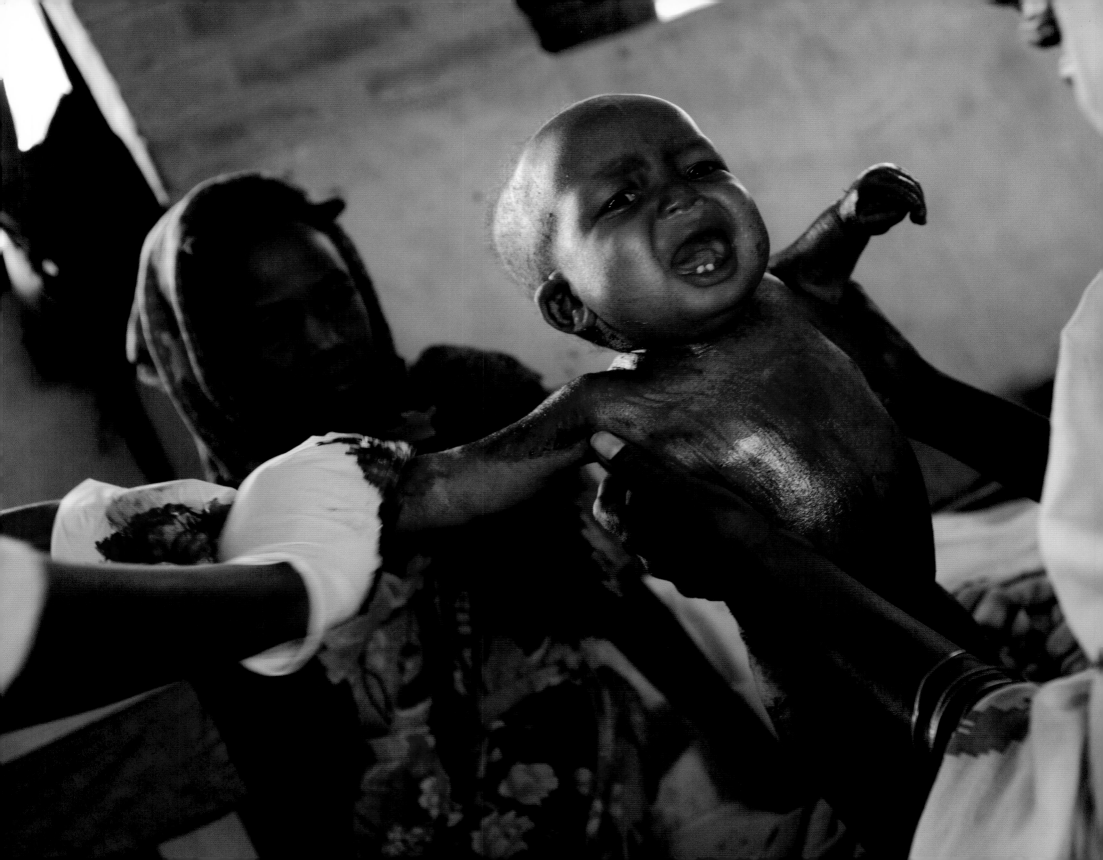

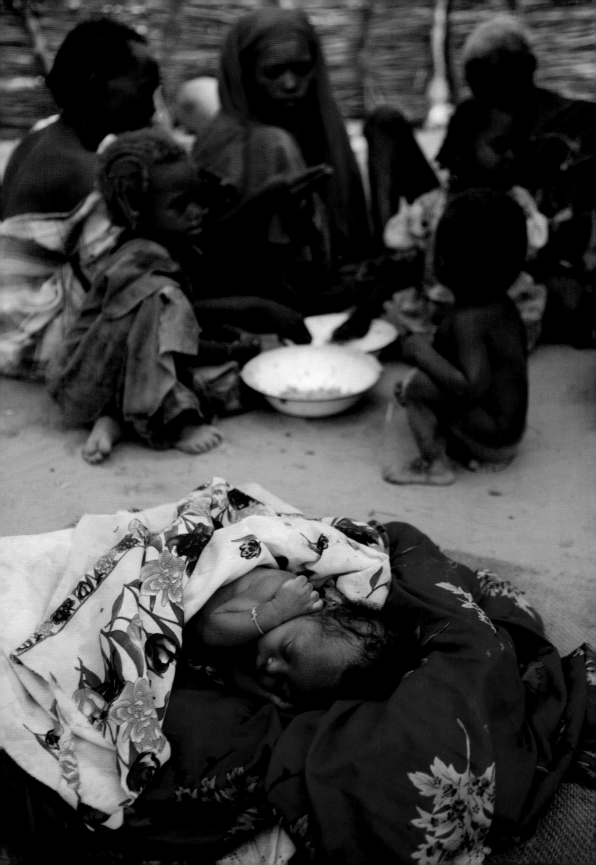

A Moral Imperative

Susan Myers, Executive Director, Holocaust Museum Houston

As World War II ended, the world beat its collective chest defiantly and proclaimed it would "never forget" the genocide of the Holocaust so that it could "never again" be repeated. The world—as history has now proven—has a short memory. The Holocaust was not the world's first genocide and it has not been the last.

The Holocaust happened, in part, because the world failed to learn from Turkey's slaughter of its own Armenian minority in 1915. After the Holocaust, Pol Pot terrorized Cambodia. Then came the so-called "ethnic cleansing" of Bosnia and then the massacre of Rwanda in 1994, the elimination of the Kurds in Iraq under Saddam Hussein, the terror of the Congo, and now the deaths in Darfur.

As Pulitzer Prize–winner Samantha Power argues in her book *A Problem from Hell: America and the Age of Genocide*, "The U.S. policies crafted in response to each case of genocide...were not the accidental products of neglect. They were concrete choices made by this country's most influential decision makers after unspoken and explicit weighing of costs and benefits."

Thousands continue to die in places like Darfur because the world has often avoided the even use of the word "genocide"—which would invoke the legal and "never again" moral imperatives to act that the word carries with it.

While we debate what constitutes genocide or civil war or tribal revolt, millions of people are being murdered or raped or left homeless or orphaned by violence.

What we must do, individually and collectively, is to refuse to stand idly by in the face of such evil and injustice. What we must do is to call upon our governments and leaders to act when action is possible and reasonable, and yes, morally imperative.

Photographer Biographies

Lynsey Addario has focused on human rights issues ranging from the effects of the Castro regime in Cuba to life under the Taliban in Afghanistan to the war in Iraq. She has documented the human and psychological toll of the U.S. occupation in Iraq, while also shooting news features on the crisis in Darfur, women in Saudi Arabia, the lifting of sanctions in Libya, and the democratic movement in Lebanon.

Spanish-born photographer **Pep Bonet** makes poignant photo essays that have shed light on some of the most heartbreaking examples of human atrocities in recent history, including Darfur. During the last four years his work has focused on Africa and the pursuit of several long-term projects, Faith in Chaos about post-war Sierra Leone, and Posithiv+ documenting the issues of H.I.V./A.I.D.S. in Sub-Saharan Africa. He is currently working on a photographic project in Somalia. He has photographed most of Africa on assignment for M.S.F.

Colin Finlay has documented with compassion, empathy, and dignity the human condition as it has unfolded throughout the world for the last seventeen years. He has covered war, conflict, genocide, famine, environmental issues, religious pilgrimage, and disappearing traditions and cultures, as well as made numerous documentaries for television. In pursuit of his passion, he has circled the world twenty-seven times in search of that one image that will make a difference in the lives of the people he photographs.

Ron Haviv has covered the fall of the Berlin Wall, the release of Nelson Mandela, cocaine wars in Columbia, the Gulf War, the flight of the Kurds from Iraq, conflict in Russia, refugees in Rwanda, and political upheaval in Haiti. He was one of the first photojournalists to cover the civil war in Yugoslavia. Most recently he covered the conflict in Sudan.

In April 2004, **Olivier Jobard** was the only Western photographer to go into Darfur as well as first photographer to penetrate into Fallujah, the Iraqi town seized by American forces, spending two weeks with Iraqi rebels. Later that same year, Olivier accompanied a group of migrants on their precarious journey from Layoune, Morocco to the Spanish Canary Islands.

Kadir van Lohuizen covered the Palestinian Intifada. In the years after he worked in many conflict areas in Africa, such as Angola, Sierra Leone, Mozambique, Liberia and DR Congo. From 1990 to 1994 he covered the transition in South Africa from apartheid to democracy. After the collapse of the Soviet Union he covered social issues in different corners of the former empire. He also went to North Korea and Mongolia. Recently van Lohuizen covered the conflict in Darfur and in Lebanon.

Chris Steele-Perkins began his first foreign work in 1973 in Bangladesh, followed by work for relief organizations as well as travel assignments. Steele-Perkins joined Magnum and soon began working extensively in the Third World. He says that, "I have been to southern Sudan a number of times. Darfur was a harsh and magnificent place, but as a Westerner, I was under the protection of relief organizations and magazines. The stories in Sudan are always about conflict and suffering and as I would fly home, I'd be thinking how grateful I was to have all the conveniences of the West at my disposal and wondering how long I could survive if I had to live as the people I had photographed there live."

Sven Torfinn is based in Nairobi, Kenya, working on assignments for Dutch and international media and N.G.O.s. Torfinn says that he found Darfur a difficult story to capture with a camera, the story is so terrible.

Acknowledgements

Proof would like to acknowledge all the people who have inspired and helped us with this project. We would particularly like to thank the following people: Jenna Bascom, Eric Brown, Nicki Clendening, Adrian Evans at Panos, Margaret Finlay, Anne Folliot, Ian Gross, Tom Hamburger, Irene Hizme, Andy Patrick, Marta Salas-Porras, Esther Siegel, Lillian Sizemore, Jennifer Stern, Mike, Tedesco, Ronnie Weyl. Karen Robinson and Mary Anne Feeney at Amnesty International have been great to work with throughout. Carmen Salcedo of Nota Productions and Betti Weimersheimer made key contributions to this project. Special thanks to Lou Desiderio for his dedication. The Holocaust Museum of Houston has lent its support from the beginning when we first conceptualized this project. Thank you to everyone at powerHouse.

Nate Kravis provided encouragement and guidance in dozens of ways. Our gifted designer Randall Lane has done an amazing job in creating a beautiful space for a horrific subject. Huge kudos to Aaron Clendening for all her work and sage advice. Colin Finlay was a driving force behind this project. Finally we owe the photographers and writers tremendous gratitude for their generosity and for the haunting beauty of their photographs and essays that have brought to light the horrible plight of the people of Sudan.

Captions

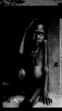

1991 Drinking water dug up from a dry riverbed during a famine in Sudan.
Chris Steele-Perkins/Magnum Photo

1991 Malnourished child in Sudan.
Chris Steele-Perkins/Magnum Photos

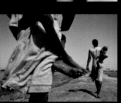

1988 Population movement from the south of Sudan. The children suffer from malnutrition and therefore are too weak to undertake the 300-meter walk that separates them from the nutritional center. They must be carried by a sibling.
John Vink/Magnum Photos

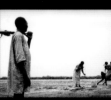

1991 Duar. Searching for water during famine.
Chris Steele-Perkins/Magnum Photos

1991 A Kala Azar patient in a hospital hut in Leer.
Chris Steele-Perkins/Magnum Photos

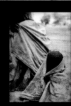

1991 Patients wait for medical attention and shelter from flies in Sudan.
Chris Steele-Perkins/Magnum Photos

1991 Hospital distribution of food for patients in Leer, southern Sudan.
Chris Steele-Perkins/Magnum Photos

1988 Refugees, Sudan border.
Philip Jones Griffith/Magnum Photos

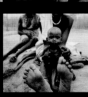

1998 Sudan.
Colin Finlay

1998 Sudan.
Colin Finlay

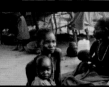

1998 Sudan.
Colin Finlay

1998 Sudan.
Colin Finlay

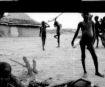

1998 Sudan.
Colin Finlay

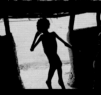

1998 Sudan.
Colin Finlay

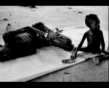

1998 Sudan.
Colin Finlay

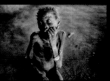

1998 Sudan.
Colin Finlay

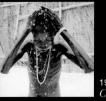

1998 Sudan.
Colin Finlay

1998 Sudan.
Colin Finlay

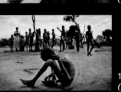

1998 Sudan.
Colin Finlay

1998 Sudan.
Colin Finlay

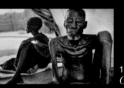

1998 Sudan.
Colin Finlay

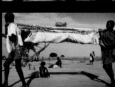

1998 Sudan.
Colin Finlay

1998 Sudan.
Colin Finlay

2004 A burned-down village. villages in rural areas are de deserted.
Sven Torfinn/Panos Pictures

oks over the
e after janjaweed
d the village. This
n the area
o animals to make
ey to the border, and
e family were too
for months, surviv-
th the area now
h the Sudanese
y feel safer and have
e.
Pictures

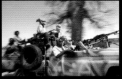
2005 Soldiers with the Sudanese
Liberation Army parade their weapons
during a rebel conference for the SLA in
Haskanita, SLA territory in Darfur.
Lynsey Addario

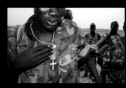
2001 Armed Sudanese People's
Liberation Army soldiers, one with a
rosary around his neck, on the plains
outside the village of Boeth, South
Sudan, Upper Nile region.
Sven Torfinn/Panos Pictures

odal Karim holds his
heir father examines
house after jan-
attacked the village.
Pictures

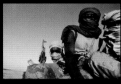
2006 Sudanese Liberation Army troops
traveling between Sheria and Mohajaria.
Kadir van Lohuizen/Agence VU

2004 A Sudanese Liberation Army sol-
dier walks through the remains of
Hangala village, which was burned by
janjaweed near Farawiya, in Darfur.
Lynsey Addario

ol holds classes in
ary post. Resources
e trunks are used

Pictures

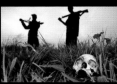
2002 South Sudan, Western
Upper Nile, Tam.
Sven Torfinn/Panos Pictures

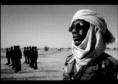
2004 Sudanese Liberation Army soldiers
on morning exercises. In the background
new recruits are drilled. They claim that
more and more young men are joining
them, mainly boys from refugee commu-
nities.
Sven Torfinn/Panos Pictures

the remains of a
Leer.
Pictures

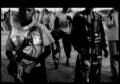
2004 Khalid Saleh Banat, 13, a soldier
with the Sudanese Liberation Army,
stands with other SLA soldiers after
training in the village of Shigekaro, in
Darfur. Khalid has been with the SLA for
2 years, joining at the minimum age for
a soldier: 11.
Lynsey Addario

2006 Sudanese rebels with the National
Redemption Front walk past dead
Sudanese government soldiers, through
a temporary military camp for the gov-
ernment of Sudan near the Darfur-Chad
border, in Darfur.
Lynsey Addario

gees arrive at a
f the Sudan-Chad
of Tine.

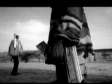
2006 Troops from the African Union pro-
tect women from the internally displaced
persons camp when they go out to col-
lect firewood at El Sherif near Nyala.
Kadir van Lohuizen/Agence VU

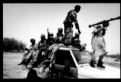
2004 Sudanese Liberation Army soldiers
on a pick-up truck.
Sven Torfinn/Panos Pictures

aced persons car-
gs on their heads,
village after hav-
outh Sudan,
Tam.
Pictures

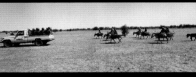
2006 Troops from the African
Union protect women while they
collect wood.
Kadir van Lohuizen/Agence VU

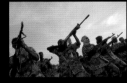
2005 Rebels with the Sudanese
Liberation Army train while attending a
large rebel conference in Haskanita,
SLA territory in Darfur.
Lynsey Addario

ration Army soldiers
There is very little
hich houses over
water is supplied by

otos

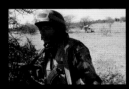
2004 Soldiers with the police division of
the Sudanese Liberation Army train at a
base in Shigekaro, Darfur.
Lynsey Addario

2005 African Union soldiers in village of
Tama, north of Nyala, after finding it
freshly burning more than a week after it
was originally attacked by Arab Nomads
backed by government forces. The A.U.
made several attempts at patrolling and
conducting an investigation on the vil-
lage of Tama after it was attacked and
the surviving villagers fled to a nearby
village, but were kept away by nomads
who continued to surround the village
and shoot at approaching vehicles.
Lynsey Addario

e Sudanese
while attending a
ce in Haskanita,
ur.

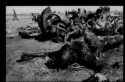
2006 The rebels from the Sudanese
Liberation Army have shot down a heli-
copter gunship from the Sudanese Army.
One pilot was killed in the crash, the
other was captured by the rebels. It is the
first proof that the Sudanese government
is still using gunships in fighting opera-
tions although the ceasefire agreement
prevents them from doing so.
Kadir van Lohuizen/Agence VU

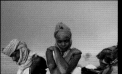
2004 Soldiers with the Sudanese
Liberation Army sit by their truck that is
stuck in the mud in Darfur.
Lynsey Addario

Captions

2006 Kalma camp.
Kadir van Lohuizen/Agence VU

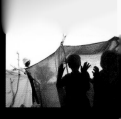

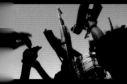

2005 Soldiers with the Sudanese Liberation Army parade their weapons during a rebel conference for the SLA in Haskanita, SLA territory in Darfur.
Lynsey Addario

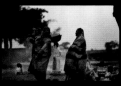

2004 Internally displaced persons.
Pep Bonet/Panos Pictures

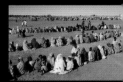

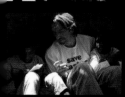

Sally Chin

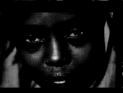

2004 A young woman in the Kalma camp.
Pep Bonet/Panos Pictures

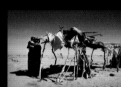

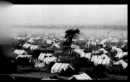

2004 Tents in the Zalingei camp for internally displaced persons.
Pep Bonet/Panos Pictures

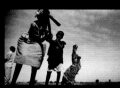

2004 A young woman cutting a tree stump for firewood, near the Kalma camp. The women have to travel increasingly further from the camp to find wood, risking their lives in the process.
Pep Bonet/Panos Pictures

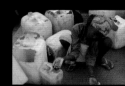

2005 The village of Tama burning.
Lynsey Addario

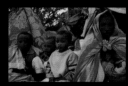

2004 Sudanese refugees arrive at a refugee camp on the edge of the Sudan-Chad border town of Tine.
Olivier Jobard/SIPA

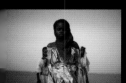

2005 Young girls leave a camp for internally displaced persons to gather firewood in Abu Shouk, North Darfur. For some the work will take more than 7 hours, leading them past government checkpoints and leaving them exposed to attacks. Girls as young as 8 have been raped, attacked, or killed trying to get wood.
Ron Haviv/VII Photos

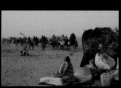

2004 Sudanese refugees arrive at Tine.
Olivier Jobard/SIPA

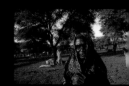

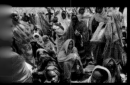

2005 Sudanese internally displaced civilians newly arrived to Zam Zam camp wait for food distribution outside of El Fascher, in North Darfur.
Lynsey Addario

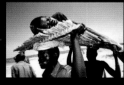

2002 South Sudan, Western Upper Nile, Tam.
Sven Torfinn/Panos Pictures

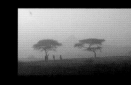

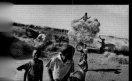

2006 Kalma camp is the biggest internally displaced persons camp in Darfur. The camp houses more then 100,000 internally displaced persons.
Kadir van Lohuizen/Agence VU

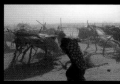

2004 A Sudanese refugee walks in a sandstorm at a refugee camp on the edge of the Sudan-Chad border, in the town of Tine.
Olivier Jobard/SIPA

2005 A refugee at the Kalma camp in South Darfur.
Ron Haviv/VII Photos

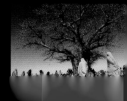

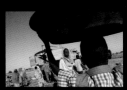

2005 Villagers from Tama carry the remains of their belongings to where they have fled at the Uma Kasara village almost 2 weeks after Tama was attacked and around 40 people were killed by Arab nomads backed by government forces north of Nyala.
Lynsey Addario

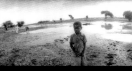

2005 Sudanese internally displaced civilians at Zam Zam.
Kadir van Lohuizen/Agence VU

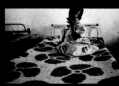

2004 A young girl at Golo hospital, which was destroyed and has been rebuilt with the help of Medecins Sans Frontieres.
Pep Bonet/Panos Pictures

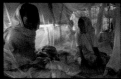

2005 An Internally displaced mother and daughter sit beneath a mosquito net while being treated for malnutrition at the Kalma camp in Nyala, South Darfur.
Lynsey Addario

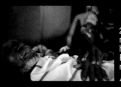

2004 A woman sits at the bedside of her malnourished husband at a primary health care clinic run by Medecins Sans Frontieres in the Kalma camp for internally displaced persons.
Pep Bonet/Panos Pictures

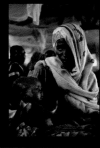

2005 Residents of Morni, an internally displaced person camp, are treated by Medicines Sans Frontiers at an emergency clinic and therapeutic feeding center.
Ron Haviv/VII Photos

2005 A woman and child recover in a therapeutic feeding center run by Medecins Sans in Kass, Darfur, Sudan.
Ron Haviv/VII Photos

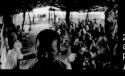

2004 Women and malnourished children at the Kalma camp for internally displaced persons.
Pep Bonet/Panos Pictures

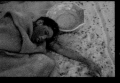

2004 A wounded young girl waits for medical care near Tine. She will later be brought to Medecins Sans Frontieres camp at Tine on the Chad side of the Sudan border.
Olivier Jobard/SIPA

2004 Woman drinking from a bucket at a water point, amongst thousands of refugees living in makeshift tents on the border between Sudan and Chad.
Sven Torfinn/Panos Pictures

2005 Villagers wrap the body of an old woman before her burial in the Kalma camp for internally displaced persons in Nyala, South Darfur.
Lynsey Addario

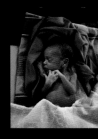

2005 An Internally displaced mother and daughter sit beneath a mosquito net while being treated for malnutrition at the Kalma camp.
Lynsey Addario

2005 Residents of a camp for internally displaced persons in Morni, West Darfur, are treated by Medicines Sans Frontiers at an emergency clinic and therapeutic feeding center.
Ron Haviv/VII Photos

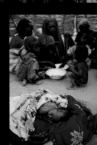

2005 Families at the border between Sudan and Chad. They plant crops and attempt to survive with little or no support from the international community.
Ron Haviv/VII Photos

Darfur: Twenty Years of War and Genocide in Sudan

© 2007 powerHouse Cultural Entertainment, Inc.

Photographs © 2007 Lynsey Addario; Pep Bonet/Panos Pictures; Sally Chin; Colin Finlay; Ryan Gosling; Olivier Jobard/SIPA; Kadir van Lohuizen/Agence VU; Philip Jones Griffith/Magnum Photos; John Vink/Magnum Photos; Chris Steele-Perkins/Magnum Photos; Sven Torfinn/Panos Pictures; Ron Haviv/VII Photos.

Text © 2007 Jonathan Alter; Larry Cox/Amnesty International USA; Mia Farrow; Colin Finlay; Ryan Gosling; Susan Myers/Holocaust Museum Houston; Nicholas D. Kristof/The New York Times; John Prendergast.

Published in the United States by powerHouse Books,
a division of powerHouse Cultural Entertainment, Inc.
37 Main Street, Brooklyn, NY 11201-1201
telephone 212 604 9074, fax 212 366 5247
e-mail: info@powerHouseBooks.com
website: www.powerHouseBooks.com

First edition, 2007

Library of Congress Control Number: 2007921925

Hardcover ISBN 978-1-57687-385-4

Separations, printing, and binding by Midas Printing, Inc.

Editor: Leora Kahn
Executive Producer: Colin Finlay
Photo Editor: Aaron Clendening
Art Direction and Design: GH avisualagency, INC

A complete catalog of powerHouse Books and Limited Editions is available upon request; please call, write, or visit our website.

10 9 8 7 6 5 4 3 2 1

Printed and bound in China